ON THE BEAT

A WOMAN'S LIFE IN THE GARDA SÍOCHÁNA

MARY T. O'CONNOR

Gill & Macmillan

Gill & Macmillan Ltd
Hume Avenue, Park West, Dublin 12
with associated companies throughout the world
www.gillmacmillan.ie

© Mary T. O'Connor 2005

The right of Mary T. O'Connor to be identified as the Author
of the Work has been asserted by her in accordance with the
Copyright, Designs and Patents Act 1988.

0 7171 3952 2

Design by Make Communication, Dublin
Print origination by TypeIT, Dublin
Printed by Nørhaven Paperback A/S, Denmark

This book is typeset in 13pt Minion on 13.5.

The paper used in this book comes from the wood pulp of
managed forests. For every tree felled, at least one tree is
planted, thereby renewing natural resources.

A CIP catalogue record for this book is available from the
British Library.

5 4 3

Some of the names in this book have been changed to
protect identity.

ACKNOWLEDGMENTS

If this ever gets into print I suppose I should thank you, Paul Malone, for your incessant badgering of me to tell you stories. If I get into a fix because of it, I blame it all on you and your fixation with the Garda Síochána. Thanks, mate.

PROLOGUE

'Charlie Alpha Base to Charlie 75,' I heard the radio call me. 'Charlie 75,' I responded, 'go ahead.' Pierce, the radio controller of Store Street Garda station, my station, continued. 'Fitz. Street need a banner. They've none working today. Where are you? We'll send a patrol car to pick you up.' 'Shit,' was my first thought, 'not another rape!' I already had three alleged rape files waiting to be written up, with damn all time allotted by my sergeant to do them. On top of that, Fitzgibbon Street wasn't even in my own district. Wasn't I loaded enough without doing their cases too? The fact that there was a great going away do planned that night for my beat sergeant, in Molloy's pub on Talbot Place, with guaranteed craic, also had a bearing on my humour. I would surely miss it now. There's luck for you, I wallowed self-pityingly. Wasn't I unfortunate to be the female Garda chosen?

Immediate guilt ran over my skin in a prickly wave. I had always promised myself that I would never turn into a heartless, seasoned bitch of a Ban-Garda I had seen Store Street station turn others into, but it seemed to be getting harder with each passing year. There's obviously a woman in trouble, I reasoned. It's better a woman be there with her. 'I'm outside the Kylemore Café,' I answered and within four minutes the U District squad car was picking me up. 'What's the story, lads,' I asked, 'another 15-year old afraid she got pregnant?' They laughed. 'No, it's more serious than that, Mary. We have a mother in custody on suspicion of assaulting her child. We need to question her.' Great, I

thought. I'm only needed in the capacity of observer. I could be going to this party yet.

I made my way to the interview room in Fitzgibbon Street Garda station. There, I saw a good-looking young woman, heavily pregnant, on a chair at one side of the table, with an inspector and a fresh-faced young male Garda on the other. I had been given brief details of the case and gathered more as I heard the men grill this woman. A 2-year-old boy lay in Temple Street Hospital with a pint and a half of blood lodged in his brain and severe burns all down the side of his torso and legs. This was the mother and the suspected culprit. A concerned friend had reported the mother after she had told her that Sudocreme wasn't working for her child's rash. When the friend asked to see the child, the mother went berserk and would not let her inside the flat. The friend who lived in the next apartment had not heard the child cry for two weeks and thought this unusual.

Although I was only there to ensure that everything was conducted with legal propriety, it became obvious that this woman was not going to break for these men. Even when they showed her pictures of her child, with his head swollen the size of a football and gangrenous scabs all down his side, she blank-walled them. She ignored the allegations that she had anything to do with his injuries, as if they weren't talking to her. All the while her little child was lying on a surgeon's table fighting for his life. Apparently the surgeon had said it was the worst case of abuse he had witnessed in his entire 25 years dealing with children.

I started to take part in the questioning, because I could see that the men's accusing tones were making the woman more steadfast in her silence. Maybe because I too was a woman, she began to respond to me. At the very least, her eyes came up to meet mine when I spoke. It was a better response than the boys were getting, so the inspector asked

her, 'Would you be more comfortable talking to Mary on your own?' She answered yes. They left.

It's very difficult to describe what it's like to be sitting beside a woman, a mother who is pregnant and about to be a mother for a second time, who has committed or allowed to be committed on her son such atrocious torture. Here was I looking at her with both horror and curiosity and thinking, how do I get this monster to make an admittance? Can she really be that cruel? Surely this mother, this frail-looking beauty sitting beside me, would not deliberately hurt her own offspring? I took a good look at the snapshots. They displayed a savage brutality on a defenceless little boy far beyond what I would have ever allowed myself to imagine, even in my worst nightmares. My initial impulse was to get sick, but I couldn't. I was here with the responsibility of finding out how this barbarous attack had happened. How do I find a communicable level here? I thought.

'You know, sometimes mothers get depressed after they have had a child and find it very difficult to look after a baby,' I said. 'It happens to lots of mothers. Post-natal depression is what it's called. It takes a lot to be a mother, with the child screaming its lungs out all the time. I don't think I'd be able to handle it,' I continued. 'I think I might get very mad at a child who just wouldn't stop crying. Does that ever happen to you?'

There were two reasons why I would have started with such a line of questioning. The first was that I thought if I could give the mother an 'out', a valid reason why she might have injured her child that was a plausible excuse and for which she might even get sympathy, then she might open up a bit more. The second reason was this. I could not believe that a mother could be so evil towards her own child. There had to be a logical reason for it.

I realised halfway through the interview, when I still wasn't getting even an acceptance from the mother that her child was injured, that I had to step outside my own experience with these questions. 'Did you throw the television at your child? Did you pour a kettle of boiling water down on top of him? Did you hold the hot iron on his leg?' The questions were met with absolutely no sense of outrage or absurdity from the mother.

Eight hours it took. The party for my sergeant would have been long since over and I was still sitting in this alter-universe, conjuring up the most outrageous questions in an effort to reach this woman's blurred reality — eight hours of probing into her own personal life of being abused while growing up, of turning to drugs and living in a daze, of suffering cruelty constantly at the hands of callous men. Her father, her brothers and all her lovers had beaten her throughout her lifetime. That's all she knew. 'I understand,' I lied.

With that, she threw herself down at my knees and cried. 'Will my son die?'

'He's not good,' I answered.

'I threw my shoe at him,' she sobbed. 'He bounced off the wall.'

'And what about the burns?' I asked.

'When I came back I found him stuck between the bed and the radiator. It was on full blast,' she said.

'Where were you?' I enquired.

'I was out getting a score. I was gone a long time,' she replied.

Finally, the admission. I knew it wasn't anywhere near the full abominable deed thrust upon the child, but it was enough to bring her to court. 'Job well done, Mary,' the inspector said to me once he witnessed her signature at the bottom of the confession. I handed the case back over to

the Fitz. Street boys to finish her off. I was war weary by the end of it. I walked out of the station in the early hours of that dark morning and I thought, wow, how did I get to here? When did I become able to deal with such cruelty? What kind of a person has my job made me?

1

God knows, I never wanted to be a Garda. There was certainly no trace of Garda blood back in my lineage. Not one O'Connor to my knowledge had ever donned a uniform. If they did, it would have been an Old IRA one. Where would you be going, a young pup like you applying for the Gardaí? But there you are. My Mammy thought I was going a bit wayward and the Gardaí was the last refuge for the black sheep of respected families. What did she do in her infinite wisdom but send in an application form to the Department of Justice for the Garda Síochána for her unsuspecting daughter. Boy, was there a shock in store for me!

The first stumbling block to get over, after the application, was the aptitude test. I distinctly recall it as it was mid-September 1991 — mid-September in the year of the most heart-shattering event of my life. My big sister Helen had just died that August, less than a month before. Helen O'Connor Tracy's life evaporated after 25 hours of battling with the sea, her boat having gone down on Long

Island Sound in the teeth of Hurricane Bob. Helen was just 28 and a bit. That made me nearly 25.

There were lots of things going on in my head and heart that day, driving to the Marist College in Athlone to sit that test. Two days previously I had run down the avenue after my father who was waving a shotgun and ranting about killing himself. He and Ma, both dear damaged souls after Helen's death, were having words. Of course, blame came out. They say it does, don't they, in mourning? Da hadn't talked to Helen for three years before she died. Sure she had gone and married a divorced American for God's sake. How could he condone that? Ma didn't believe he deserved to mourn. A tough man like him getting people's sympathies wasn't fair, was it?

It's hard to describe what I saw in my mother that time after she lost her eldest, her best friend, her soul mate. She came back from America with her dead child's body in a cast iron coffin. When I took one look at my Mammy, I knew she might as well have been in that coffin too. She was no good to any of us after that. Her lights just went out. All hope, all joy, all anything to do with the future just expired. Da? Well, Da was a doer, and what does a doer do with death? You can't stop that one, Da. A big strong workhorse of a man, his heart was broken but he couldn't speak it. He knew he was wrong but he couldn't admit it. He knew he couldn't right this one, so he took a gun in his hand and threatened to kill himself. He didn't. I called him a big emotional, blackmailing buffoon, so he told Ma he didn't do it for my sake, not hers. That helped their marital relations lots!

I didn't eat a morsel of food for three weeks after Helen died. I couldn't figure out how the one person in our family who was due to be famous could be taken like that. It reduced everything else in my world to nothing, less than

nothing. This unfathomable event was so huge, so untouchable. I cried at everything, every thought and every memory, but particularly at the ugly face in the coffin that was eternally etched in my brain. Helen looked horrible in death because she was one that had been so much alive in life. Now her death took the life out of all of us.

So when I was going to this aptitude test, as you can imagine I wasn't much in the humour for it. I had threatened that if any of the exams were too difficult I was going to walk out. Now I don't know whether it was divine inspiration from my dead sister or whether my brain was on a different plateau with all the emotional angst I had recently gone through or whether they were just easy questions, but that aptitude test turned out to be a breeze. I was almost disappointed it went so well. There was I wanting the world not to offer me anything. I had no notion of being a Garda, but those bloody gods just kept conspiring to get me in. It reminded me of Sr Stephen, my religious education teacher in secondary school, giving us a lecture on vocations. 'I never wanted to be a nun,' she said, waving her hands vehemently. 'I never wanted to wear a veil. I never wanted to be nice to people all the time. I never wanted to be at this praying lark. But I got the fecking calling.' Boy, how those gods can conspire, and conspire they did for Mary T. O'Connor was called up for an interview.

'The Gardaí?' Geoffrey, my social administration lecturer in UCD, roared at me when I told him my plan. His eyes were even more scathing, wrenching through me as if I had crossed over to enemy lines. 'Why would any intelligent person want to join that archaic, heartless institution?' He obviously hadn't been keeping a chart of my lack of attendance at lectures in my third year of a social science degree. I had never been what you would call an 'applied'

student. My mother knew me well with her rescue operation.

I had heard stories of these Garda interviews and how daunting they could be — eight big men sitting on one side of a table hell bent on unsettling the interviewee. It would be difficult, but I was lucky. Again I had my mother and her wistful advice at hand. 'Mary,' she said, 'when you sit down in front of those men, undress them in your mind. Bring them all down to naked pot-bellied Buddhas, because that's all they are. They're only human. You just remember that. They all have to go to the toilet too.' So I was ready. I was ready to laugh the whole way through the interview, and that's exactly what I did. Every time one of those big men asked me a question, I pictured him trying to do a number two after three days of constipation! It certainly kept a bright, bubbly smile on my face throughout the interview. I walked out the door thinking, you definitely blew that one, girl. You enjoyed it too much. Fate thought otherwise; I was called for the medical.

I can remember the medical so well. Just like the aptitude test, it centred round the death of the second of the three strongest people to have touched my life. My grandmother's funeral took place the day before, and my mother and I had spent six weeks relaying in and out to the Geriatric Unit at Tullamore General Hospital doing a vigil by her side. I loved my grandmother. A Kerry woman, she was a sister of nature with a quiet, inner, proud strength. That was my Gran, proud right up to the last. They put those old people's nappies on her just once in the hospital and she ripped it right off. She had made it to 92 without them. 'You're not going to reduce me now', she said. It's what got her in the end, the effort of getting out of bed to go to the toilet. The push on the loo burst something in her brain and she never came back to us after that. Her death

was so different to Helen's. I could really see it as a passing over. She had wanted to die and had lived too long, for her heart was strong. I was happy for my grandmother in the end. There was a peace in it. So I celebrated at her funeral — a tad too much indeed for one that had a medical the next morning!

I arrived at the gates of Garda Headquarters in the Phoenix Park in my ancient Renault 4 that had a hole in the floor and had to have the brakes pumped to stop. With a thumping hangover headache and anxious at the alcohol level my urine sample might reveal, and a ferocious chesty cough picked up from the hospital but which didn't stop me getting ten fags in beforehand, I presented myself. It was to be an all-day affair — all day without fags, staring at 11 fit-looking women. Again, I was half-glad the competition looked so good. It meant I had less chance of getting it.

I was reared in the middle of four brothers whom I love but who were just dreadful growing up. Those four brothers could muster up many a story that naive Mary believed. One of their real beauties was that I'd have to take off all my clothes for this medical. 'And that means everything, Mary', they assured me. I was very shy in those days and the notion of taking off my jumper, never mind anything else, petrified me. Every time one of the girls came out from the doctor's surgery I begged each of them to give me every tiny detail of the screening. They obviously copped my terror and as they were more than willing to get rid of any rivalry, they each in turn verified what my brothers had said. 'Yes, Mary, you have to take off all your clothes, even your knickers!'

Of course it had to be a male doctor. Male doctors and I have a history ever since when I was 17 that old perverted bastard doctor from Glasnevin, knowing I was only a vulnerable student and not a permanent resident of his

constituency and too sick to know any different, pulled up my nightdress and fondled my boobs. 'There, there, aren't you great for a girl who's so ill,' says he and his dirty hands snaking their way around my body. So, no, male doctors and I generally don't get on.

When my turn came before the Garda surgeon, I had worked up my nerves so much that I was in a floostering frenzy. Steeling myself for the impending indignity, I took a deep breath. Come on, girl, just get it over with. Then I burst in through the door and splurted, 'Do you want me to take my knickers off now, doctor?'

He laughed. Of course he did. He laughed and thought to himself, I've a good one here. Maybe that's why, when I said I smoked 40 cigarettes a day, he said, 'I'll put ten on the form.' When I said I didn't do any exercise, he said, 'We'll say running is a hobby of yours.'

Well, desperately unfit or not, spluttering up phlegm like the new time, with all the competition smirking to themselves that I was a goner, or not, those gods still weren't done with me because less than a week later the envelope with the printed harp was dropped in through the door. 'I am pleased to inform you that you have been successful in your application for An Garda Síochána. You are required to report for training to Garda College, Templemore, at 1 p.m. on 6 April 1992.'

Oh God!

2

What a spiffing reception it was, that first daunting day when we walked through the gates in Templemore. All the gloating parents came along to deposit their special darlings into the Garda College. They were well pleased with the delightful show put on for them. The big guns of the college were most hospitable — everyone in suits and smiles on all the faces (except the look of horror on some of the girls who recognised me from the medical). Julie McCormack, a good, country lass, came over, whacked me on the shoulder, threw her head back laughing and roared, 'I was sure you wouldn't get through.' I liked her instantly.

After the refreshments we were ushered into the grand hall where supers, chiefs, assistant commissioners and the like lauded the merits of this current intake of student Gardaí. Seventeen and a half thousand applicants, and 'your children are the very first class chosen. They are the cream of the crop,' Assistant Commissioner Laurence O'Toole assured the parents, and 'they are going to do you

and this country proud.' Servers of the community, 'we will shape your brilliant children into pillars that can handle anything.' My parents walked out those gates that day proud as punch if not slightly scared it might all overwhelm their little Mary.

Meanwhile, little Mary was eyeing up the talent. Jesus, I never saw so many fit, good-looking specimens of men in the one room together in my life. We went into the lecture theatre for our induction and each boy that came in through that door just kept getting taller and more handsome than the last. I was in my element. Fifty-four boys to nine girls — pretty good odds in any girl's book!

They were a motley crew in our group, all shapes and sizes, all kinds of previous occupations: printer, painter, postman, electrician, accountant, model, farmer, to name a few. A lot had done a year or so in college, which made me feel more at home. Most of the intake had some connection, by relation, to the Gardaí, and a lot seemed to know exactly what was what but more important they were able to recognise various ranks and knew how to address them. At that stage I still innocently believed everyone in the world was on an equal footing. I would soon learn.

The accommodation was wonderful, girls in one block, boys right across the square in another. Every student had their own room and it sparkled: bed, table, wardrobe and sink, all spanking new. I brought what we were instructed by post: tracksuit, runners, suit, casual wear, basic things, so my room still maintained its comfortable but regimental look. I was amused at what some of the other girls had lorried in. What one girl, Majella, couldn't fit into a car wasn't worth bringing. There were baskets to beat the band, duvets, clothes strewn everywhere, radios, CD players, hair-dryers, a million shoes, teddy bears, scarves of every colour, make-up, boxes of jewellery, clocks and bowls. We were to

have great fun every Tuesday morning for the next six months at room inspection trying to hide all that stuff away.

On the first official morning without our Mammies, the 63 of us were divided into three classes, three girls in each. I was put into class 1 with Majella. We got our class IDs that day. Mine read Mary T. O'Connor Class 1/02 and just under my picture I was given the number 007. 'My name is Bond — James Bond.' I was starting to feel the power already.

The very first class was drill under the direction of Sgt O'Neill. Out on the square he lined us up according to height. Some of the boys in this group were 6 foot 7. Two of the girls were six footers. I'm 5 foot 7¾ and I felt like a dwarf. It took a full 40 minutes to measure us all up, one big line, the two tallest on either end running into the smallest in the middle. Majella was the smallest; I was the fifth smallest. This is important because this was to be my permanent position.

With everyone correctly positioned, the sergeant gave us our very first address. 'So, you think you're the cream of the crop,' he bellowed. 'Whipped cream curdles quick and that's my job, to whip you little shits into shape and get rid of the whey. And don't you ever, I said never, undermine my authority, because I, my friends, have total control over your lives for the next six months.' The antennae of my sixth sense were running into high alert. I knew the mood was a-changing. I quickly forgot I was Bond!

Our initiation into institutionalisation was intense. We were locked inside those gates and eight-foot perimeter walls from Sunday night to Friday evening. Every time a student stepped across that gateway required a signature. There was a Garda on duty 24 hours round the clock. If you went into the town in the evening you had to sign out, and God forbid you got drunk because those sign-in signatures

were scrutinised every morning. A shaky signature could get you blocked. And you didn't want to be blocked. Behaviour was everything. 'Remember, we're doing you a service because your behaviour will be watched all the time when you're out in a community.'

The seeds of paranoia were set early. Tutor after tutor came in, introduced themselves with smiles and told us how we were part of the new training regime that understood we were individuals and would be treated as such. They went to great pains to inform us how lucky we were to be part of this new, forward-thinking training, because in their day you could be hanged for nothing. Now it was your own choice, because now they gave you the rope so you could hang yourself. Charming!

One particular tutor pontificated for an hour on how imperative it was to start cutting undesirables out of our lives. 'I used to have a friend who smoked cannabis,' he said. 'I don't any more. I got rid of him.' He encouraged us to do the same. Anyone who wasn't of impeccable character should be stricken from our list of friends. I wondered what my social science comrades would think of that. I wondered what my free-spirited college student pal, whose fantasy was to make love naked under the cherry blossom tree as the petals fell, in front of the Arts Block of UCD, would think of that.

I wondered what our tutor would have thought of the 21st birthday party we threw for our flatmate, Smithy, a few months before, which necessitated an emergency meeting in the middle of the night of the Anglesea Road Residents Committee in Ballsbridge. They gave us 24 hours to vacate the premises. We had a record-breaking five Gardaí calling to the house to quell the chaos that night. Sure, if I was to follow our tutor's advice I would have had to dissociate myself from myself for all my 'disreputable behaviour'

over the years. I was glad I wasn't 18 joining these 'brain infiltrators'. At least I could discern for myself what to digest and what to eliminate as nonsense.

Along with the nonsense there was a lot of discipline and everything in that college ran like clockwork and by seniority. We might have been the first class of our intake but we were only the junior phase i's, the lowest of the low. In the college at that time there were also senior phase i's three months ahead of us who despised us, phase iii's nine months ahead of us who thought we were beneath them, and phase v's (real Gardaí at that stage) who tolerated us so long as we knew our place.

Lunchtime in the canteen was like watching winter feeding on the farm. The pecking order quickly came to the fore. Having been reared on a farm, the middle child of seven, I used to love getting up earlier than everyone else in the morning to have at least an hour to myself before the mayhem started. One of my favourite pastimes was watching cattle. I would sit on the gate of the field and watch the cows and the ordered chain of command. There's a whole status structure in the world of animals. It's a world of no mercy. The canteen in Templemore somehow brought this back to mind. I saw senior phase i's physically push their juniors out of the queue just to assert their authority. And I saw it condoned by the bosses because 'you're in the Gardaí now where you don't question seniority'.

Those first few weeks were a shock to the system — being roared at all the time, racing from drill class to lectures, from circuit training to running classes, from swimming classes back to lectures, and trying to gobble down lunch in five minutes. It was hectic, but brilliant. I was living on the edge of my emotions all the time. I suffered paranoia, fear, exhaustion and muscle spasms from exercising parts of the

body never before afflicted. Those hamstrings didn't know what hit them, but they did scream at us. The hamstrings, the quads, the abs, the buttocks, the arms. Every goddamn part of the body screamed, please have mercy, but it was relentless. I can still vividly picture Majella and myself down on all fours clutching on to the banisters, dragging ourselves back up to the bedrooms. All I could do was roar laughing. I think, in hindsight, even the brain muscles went a bit mad. Still, it was great. We were all in this boot camp together so there was a fantastic sense of camaraderie among us. Nobody knew what the next torture treatment would be, but it would be a mandatory torture for everyone. It was exactly the therapy I needed at the time to come out of mourning. All I had to do was follow the instructions; there was no time to think and I loved it.

There was one thing, however, that I didn't like, and that was inspection. Every Tuesday morning before class, out on the square, we had to undergo this intimidating ordeal. Our first experience of this dreaded task occurred when we hadn't yet been issued with our uniforms and we were all in our interview suits. It was fine for the boys in trouser suits and sensible shoes, but for us girls in our short skirts and not so sensible shoes it was a nightmare.

All the other phases who were in uniform gathered their troops professionally and marched out on to the square in sweet synchronism. They lined up on the square watching and, I'm sure, smirking at our floundering attempts to get into formation. Martin Mulvihill was at the front of our gang as he was one of the tallest.

Poor Martin lacked bodily co-ordination so when a sergeant would roar left, his brain misconstrued it to mean right. Most people march naturally. When the right foot goes forward, the left hand swings forward with it and vice versa. Not Martin's. The confusing signals were like one-

second paralysis delays whereby he ended up looking like a stiff mummy with hands flailing out of sequence.

Anyone who knows anything about drill knows that when the lead men are out of sequence it doesn't bode well for those following. So that morning our performance resembled the Keystone Cops tripping over each other, the front guys taking long strides, the girls who were in the middle in tight skirts and stilettos tottering frantically to keep up, and the remaining lollopers behind falling on top of the girls. It was an embarrassment. And, in the full view of 500 other people we were keen to impress, it was anything but dignified.

It wasn't just that farcical show that I found mortifying that morning. It was what followed. When all the phases eventually lined up, out through the front door marched three very important looking men. They had an intense, austere look about them and I knew from their demeanour that these were the power boys who were the real ball-breakers. Slowly they marched up and down through the troops within four inches of everyone's face, scrutinising haircuts, dandruff on uniforms, and examining how straight those pleats were ironed into the trousers. Brass belt buckles, buttons and whistles were tested for sparkle and the spit on those shoes 'should show the reflection of my face on them', I heard them admonish. By the time they came to inspect their junior phase 1's, we were like jelly.

That morning as they approached me, I felt nauseous. These men, in my face, looked boldly into my eyes and then slowly examined me from top to toe, whilst I waited for their comment on how presentable I was, or not. It's hard to put the finger on that feeling that morning. I felt denigrated. It didn't sit well, but it was a feeling that would dissipate with time. You see, everything in training had a purpose. Their intention was to break you down so they

could build you back up again stronger. Unfortunately the psychology did not work for all of us. But more about that later.

I got rid of all my beautiful locks because of that bloody Tuesday morning ritual. The day I started in Templemore I had a fabulous mane of wavy red hair down to my waist. But for those first few weeks it was constantly wet with all this tearing around, showering, swimming and sweating. As for trying to get it in under a hat. Well, that was beyond me.

Lorraine Boyle was born into it. Her father had been a Garda and so had her mother. She was born and reared in Templemore. I envied her because none of this was alien to her. She glided into the Gardaí like a graceful swan, super fit, a super swimmer and a super looker, always smiling. But the most enviable quality Lorraine had was that effortless ability to put a perfect pleat in her hair in two seconds flat. I looked on in awe particularly every Tuesday morning. When I'd leave my bedroom, having spent ages in front of the mirror, the hair and hat would be fine. But without fail, by the time those inspection men would be within a couple of feet from me, at least three devilish curls would have sprung out from under the hat and inevitably I'd get a tap on the shoulder to indicate a black mark against me for untidiness. My hair and that hat were never going to be best friends so one of them had to go, and I was too curious about the training to quit just yet.

So one weekend my brother Morgan went with me to Mary's Hair Salon in Athlone. The two of us sat side by side on stools and Morgan asked for a No. 2, almost a shaved head. The job was done in a jiffy. When my turn came I pointed at Morgan and said to my stylist, 'That's what I want too.' Her jaw dropped. 'You're joking.' It took half an hour to convince her, but eventually the electric shaver was taken to my head and my long locks lay lifeless on the floor

around me. There'd be no more blockings for me. Do you see how serious she is about this career? Look what she's willing to sacrifice, I imagined them thinking.

The next Monday morning they didn't think anything of the kind. Business as usual with no comment. And that's the way it was to continue. Slowly the realisation that you were only a cog in a wheel and not an individual began to dawn. You were only a number in a massive organisation that was around a long time before you were born and would be there a long time after you were gone.

3

We got into a routine, a very regimented one. Once we were issued with the uniforms all classes were to be conducted in them and they were to be presentable at all times. We were blending in more and more with the other phases. There would be no distinction between people in this pod except for seniority. We were given the code of how one conducts oneself in the uniform. Superintendents and upwards were to be saluted and called sir. Indicative of the patriarchal system of the Gardaí, no one knew how to address a female officer. All ranks could be distinguished by their epaulettes. An ordinary Joe Soap Garda has numbers on the shoulder. These numbers are unique to that Garda and tell you from which district a Garda operates. C75 is Charlie 75, Charlie district being Store Street, Dublin. A sergeant has metal stripes and numbers; an inspector has one red and gold bar on his/her shoulder; a superintendent has the red and gold bar plus a red and gold diamond; a chief has two diamonds, and so on. Rather than take all that in, I found it easier just to have

two categories: the blue shirts with whom you could get away with a bit of cheek, up to and including the rank of inspector; and the white shirts, the ones to lie down under and allow your body to be used as a mat for whatever you say, sir, who were superintendents and upwards.

The studies were difficult. I don't know where this notion of the thick Garda came from because you certainly couldn't be thick and get through all that law. I had done two years in Athlone RTC studying accountancy and three years in UCD studying social science, and yet both of them put together wouldn't have produced the workload that was pushed on us in the college in Templemore. Pressure was exerted at every turn. I surprised myself I was coping so well.

It was easy to forget there was an outside world when you're cooped up in a pen with 500 others all in the same boat. You begin to create your own little universe and fall effortlessly into your slot within it. I can see now how religious sects get so many followers. If you're lost on the outside but you have this family that tells you you're brilliant, you just need discipline, it's comforting to know there's a bed made up just for you and you don't need to concern yourself about how it came to be.

I had been a lost soul for a long while. I was 25 years old and before I joined the Gardaí I didn't have a clue where my life was going. From the time I left school it just seemed like one failure after another. I began a course in Trinity College after the Leaving Cert, management science and industrial system studies. I was a fish out of water and I quit after two months. I tried my hand at a secretarial course in the local tech in Ferbane after that. The nuns from St Saran's next door, where I went to secondary school, threw their arms up in despair, telling my mother I was wasted. I then told my parents I wanted to be a nun. My father was delighted.

He had done eight years training to be a Pallotine father in Thurles before he met my mother and always had a love for the religious life. He contacted the Medical Missionaries of Mary in Drogheda and a date was booked for my interview. The morning I was to go was a cold, dark winter's dawn. My father went out to warm up the engine of the car. Meanwhile my mother stood at the front door and cried. She begged me to reconsider. 'Oh Mary, you're too young to make a decision like this. Please live a bit first.' She was right, of course. I relented and never made it up as far as Drogheda, and I'm very thankful to her. I couldn't imagine a world without sex now. Thank you, Mammy.

I was a barmaid in Butlin's, a pastoral assistant in Athlone RTC, a farmer for a year at home and I had spent a year in London doing accounting and clerical work before homesickness got the better of me. I had done a bit before the Force got me, but as much as I thought I had a singular mind I fell into the nestling arms of the Gardaí without any pain. They grabbed me and nothing existed outside those gates.

The changes were subtle. Maybe I was forced to think differently about people, but people were definitely changing towards me, regardless. Everywhere I went now I was to be introduced as Mary the Garda, and it did have a profound effect. At discos when I'd be asked up to dance, it didn't take long to be aware that as soon as I mentioned that I was training to be a Garda, the dance couldn't be over soon enough. Women love a man in uniform and a male Garda has to fight off the admirers. We females are stonewalled. I could never quite put a handle on it, but I think it's the notion that men don't like their women to be more powerful than them or maybe they're afraid we'll handcuff them to the bed and run off and have sex with someone else instead!

I discovered there is nobody in this country that doesn't have a story about a Garda. Ninety-nine per cent of them is the story of 'the bad bastard who pulled me for doing 42 kilometres an hour in a 40 kilometre zone. Why aren't you out there catching the real criminals?' Was I to be answerable for every decision every Garda ever made from here on in? I could now sympathise with doctors and nurses who must get a similar incessant lambasting about rotten medical conditions. I began to lie about my occupation just for peace, and had to threaten my friends to a beating if they let it slip either.

Even my friends and family changed, though they'd never admit it. Growing up I had always been considered perceptive about people. Now if I dared pass a comment about a person, it was 'the Garda coming out in you'. Since when did the Gardaí have the copyright on free comment? There was to be a long process of growing into the uniform ahead for me.

But I was happy to be in it. I was busy. I was getting fitter than I had ever been in my life. The brain and the body were getting stronger every day and I was learning new stuff by the hour. I had never experienced this before. To have my attention held for this length without getting bored or without getting itchy feet was quite an achievement and said a lot for the diversity of the training.

I couldn't mention training without making reference to the god of Templemore, a man to genuflect in front of, the one and only, the unique, never again to be repeated or cloned, Reggie Barrett. Reggie was an institution in himself, known by every Irish Garda that ever trained for the last 40 years. He terrorised, intimidated and frightened the shyness out of the hardest of men. Men have wet their pants under the rule of King Reggie. He was commandant over physical instruction and despite having suffered three heart attacks,

by the time it came to our turn beneath his command he was still a gale force to be reckoned with.

The first rumour we heard about him was 'back in the days of the old training' when the boys were in dormitories. At three o'clock in the morning, if Reggie took the notion, he'd dress up in camouflage, sneak into the dormitory and crawl under the beds uprooting the lads one by one till he had made his way to the end of the room. 'I want you all in full battle gear in two minutes out on the square, you know', he'd roar and he'd run the poor misfortunates out the road and up the Devil's Bit mountain in rain, hail or snow.

Apparently he had mellowed by the time he got round to us! We were warned he was still a maniac though and not to get on the wrong side of him. This intrigued me to the extent that I must have had one of those quizzical looks on my face in that first class that he immediately honed in on and wanted to get rid of. 'C'mere to me you, you know,' he shouted, big fist gesticulating in my direction, with all 21 of the class standing in the middle of the gym looking on. I stepped out of the line towards him. 'You see those bars that run up the side of the walls there like a ladder, you know,' the big strong arms boldly driving home his words. 'I want you to climb up those bars right to the top, you know. Now, woman!' I ran over to the wall, my heart pulsating ferociously, and climbed the trellis. As I got to the top, another roar. 'Hang out of the top bar there by your hands, you know.' I hung out of the top bar. No further instruction. He left me hanging till my arms ached, then started to wobble, and eventually my whole body went into a shudder. I clung on desperately for dear life, but my hands couldn't bear it any longer and the bars slipped through my fingers. I fell to the floor with an almighty thud. As I stumbled to my feet the lecture started. 'There you are, you know', hands always on the go. 'No upper body strength,

you know. Women have it all in the thighs,' said he, slapping his legs. 'Us men have it in the arms, you know,' and he flexed his biceps proudly. He was a practical man, Reggie. Everything was explained by demonstration, much to the chagrin of whichever poor soul he happened to pick on. I seemed to be picked on a lot.

I couldn't swim when I started my Garda training. I still couldn't swim by the end of it. It wasn't that I wasn't eager to learn. In the beginning I was so determined to master this swimming lark that in spite of aching limbs from all the exercise during the day I even went into the swimming pool at night with Majella to try it out. Reggie caught sight of me one evening. Again I heard the by now familiar 'C'mere to me, girl, you know.' I went over to the side of the pool at the shallow end. Reggie looked down at me. 'Tonight, I'm going to teach you how to dive, you know. Get out of that pool.' I followed the master to a quarter way up the pool, which must have been about 4½ feet deep. Nothing too frightening about that. I had ventured that far before so I didn't see it as a problem. He got me to jump in, feet first, into the water. No sweat. Got that one. Thank you very much, sir.

'You're not finished yet, you know. Follow me.' Out on the edge of the pool I walked behind him up to the deep end. Now the deep end of the swimming pool in Templemore really is a deep end. It's 17½ scary feet to the bottom. 'Jump in,' says he. 'I don't think so,' says I. He called Majella over. He instructed Majella to jump in, feet first, into the water. She did. Reggie started counting. 'One thousand, two thousand, three thousand, four thousand, and she's up. Look at that, she's a water baby. That's all you have to do. Put your hands straight down by your sides and just jump in. Simple as that, you know.' God, he gave me such great encouragement that he did rouse me to be brave enough to

do it. I stood at the edge of that pool, clenched fists held in tight to my side as instructed, and took a leap of faith into that pool. One thousand, two thousand, three thousand, four thousand — and I'm still going down. Five thousand, six thousand, seven thousand, and Mary hits the floor. Oh my God this shouldn't be happening. I'm still under water. Fuck! Luckily I still had my eyes open and I saw what I thought was a bar coming in towards me. I made a grab for it, but as quick as I saw it, it was gone. By this time I was starting to panic, my breath was going. I was struggling when again I saw that saviour bar come in towards me. I caught hold of it this time and glorious good Jesus God I was pulled out of the pool. But my knight in shining armour was not the mighty Reggie Barrett. Oh no, he was nowhere to be seen. Another instructor had seen what had happened and ran the length of the pool to save me. The next day I heard that Reggie went into a class and said, 'A young one, last night, you know, jumped into the deep end, you know. I didn't know what was going to happen, you know, so I had to get out, you know.' No, I don't know, Reggie. You abandoned me and left me to drown, you know. I wondered that morning if Reggie himself could swim.

Was that supposed to instil a love for the water in me? I never did well at swimming after that. Reggie still couldn't fathom why. So we played games with each other from there on in. I got used to them eventually. I learned there were two ways to take torture: you could lie down under it and let it stress you; or you could rise above it, knowing you couldn't change it, and allow it to help build your character. The one thing I did respect him greatly for was the fact that though he roared, shouted and belittled you, he always dealt with things there and then. There was no report writing by Reggie. There was no behind-your-back file

secretly brewing up through the ranks that many of the other instructors were capable of, as many a student can tell, myself included.

4

There was a perpetual sense of big brother watching you at all times in the college, regardless of the time of day. Four o'clock in the morning could see a Garda from the guardroom sneaking around the bedrooms, listening outside the doors. We were eternally being secretly eyed and even though the overt declaration was that of the musketeers, 'one for all and all for one', underneath that lay a subtle indoctrination of mistrust. 'If you do one thing out of place, rest assured we will find out. We have the ways and the means, and your comrades *will* spill the beans. Trust no one! We will get to the bottom of even the slightest misdemeanour. We are the master interrogators.'

Our first experience of this happened within a month of our arrival. Perhaps our group had been too relaxed and needed knocking back 'just to let you know who's who'. Maybe we were getting on too well together and we hadn't quite fallen into the one upmanship, competitive outdoing of each other. Or maybe we just weren't frightened enough

of authority yet. For whatever reason, all the classes' boats were about to be rocked.

In our class they chose Cormac to make an example of. Cormac was what you would call a real sound character who always saw the best in everything and everyone and was delighted to be training as a Garda. One Sunday night he came back from town pleasantly pissed, partook of witty Corkonian repartee with the Garda on the gate, sauntered into the college and committed the crime of engaging in a singsong in the Rec. Hall. Sacre bleu! Incredibly, behaviour unbecoming of a gentleman was what he was charged with. He was frog-marched up to the superintendent's office first thing Monday morning and officially cautioned and charged with this grave offence. Witnesses were called in and full statements taken. Threats of being thrown out 'if you don't testify against Cormac' were bandied about. It was a punch in the belly to us all. No, they weren't joking. This was a serious investigation into misbehaviour and don't anyone make light of it. 'There'll be no fun for ever more in my jurisdiction.'

This tribunal lasted three months, three months of dark clouds hanging over Cormac's head, but a hidden message to us all — 'We control every breath you take.' Every Friday evening without fail, just an hour before break-up for the weekend, in order to ensure that the weekend would be wrought with guilt, the announcement would come over the intercom system: 'Would Cormac please go to Superintendent Ludlow's office.' And every Friday evening after that meeting Cormac would come back to us, head weighed down with the impending threat — they were still considering whether to retain him in the job or not. It was a threat for us all. There was the furtive warning that fraternising with undesirables could be detrimental to progress in the job. Don't touch the tainted! I was to find

out, in my time, that this filtered through all stages of the Garda Síochána.

Some of us continued to have great craic though. We just learned to lie about it. We learned to sign in for each other at the gate. The inebriated were smuggled in with blankets over their heads in the back seat or the boot of a car, if it had been a particularly boozy night in town. We had an underworld of fun, but you had to be careful who you let join.

We had a good team in the women and we got away with a lot more than the boys did. Someone got the brilliant idea of suggesting to one of the senior female officers that the Gardaí from the guardroom were a bit voyeuristic in their night-time rounds of the women's block. And how were we to feel safe getting up to go to the toilet in our nighties when a strange man might be treading the boards of the corridors? We gained a victory — no more nocturnal visits. We revelled in the freedom of midnight madness. One night I went to bed early, only to be woken by two of the girls coming in from the Rec. Hall. They had a few drinks on board and no one was going to get any sleep for a while. A crowd ended up in my room and the party got going. I think we got round to talking about self-defence training and the two girls decided to give a demonstration. It was hilarious, two grown women throwing each other on the floor. All we needed was the mud. Boy, was the guardroom Garda missing out tonight! It turned boisterous and progressed to the full onslaught of a wrestling match. I was just thinking it might all end in tears when, whack! There was a sound that could only have meant severe damage. One of them lay on the ground, blood pumping from her forehead. We cleaned her up, but it was obvious stitches were required, so a story was needed.

I was the sober one, so I was to do all the talking. 'You say

nothing. I'll say you're in shock', I said. I rang the resident medic, who in turn rang the doctor and we drove into town to his surgery. We told the medic that the injured girl had had a nightmare, jumped up out of bed and smacked her head on the door of the wardrobe that had been left open. The medic seemed to believe it, but we had to tell the doctor the truth because of the amount of drink consumed. I could tell by his reaction that he empathised with our dilemma and proceeded to insert three stitches in her forehead. We knew he would say nothing.

It's a pity the doctor who tended to Alan O'Brien had no realisation of where his medical report would end up. Alan went off one Friday evening and did not return on the Sunday night. He arrived back to the college on Wednesday but reports had to be written. What actually happened and what Alan wrote in his report is this. He had a match on Sunday afternoon in Dublin. In the midst of a tackle during the match Alan received an injury and had to be taken to hospital. As a consequence of the belt on the head, he suffered concussion and was kept in overnight. It could happen to anyone. Thankfully he regained full health and was right as rain on his return to the college.

One would tend to compliment a person for engaging in a healthy extra-curricular pursuit — not so the increasingly incomprehensible institution of Templemore. No, yet another full investigation was launched. Medical reports were sought from the hospital. As it happened, and to Alan's misfortune, there was only a locum on duty the night of his visit, and not one who was proficient in psychological affairs at that. The locum had written on the report that Alan's ramblings caused concern, words that would affect Alan's life for the next four years. Because of those words, the authorities in the college expressed grave reservations about Alan's mental health. Like Cormac, he was hauled in

and out of supers' offices interminably. They kept him dangling for a year, and the day before attestation they sacked him — a cruel, vicious undercut, and yet another lesson for us all.

Alan took the Commissioner of the Garda Síochána to court for unfair dismissal. After a lengthy legal battle he was eventually reinstated, one of the few people ever to have taken on the Force and won.

Hector Payne didn't win. Hector was proud to have made it into the Gardaí. This is the life he wanted and he thrived on it. He pooh-poohed any cynical comments I would come up with about the training and he was a fantastic friend to have during it, full of encouragement. He volunteered for everything. He helped run the bar; he guided secondary school day-trippers round the college with great enthusiasm; he joined every club there was. He played rugby, hurling, football and golf. In fact, Hector could turn his hand to any sport. He even had the patience to go jogging with me in the evenings to try and build up my pathetic times. He was a helper bee in those days when I was such a disaster physically. I was smoking 40 cigarettes a day. I just could not run, but Hector was determined to get me through. He had great tolerance. He also couldn't lie, and that's how they got him.

Hector was obvious. Because of his height he could be identified in a crowd a mile away and he had a laugh that could be distinguished amid all others. With any hint of trouble he would be the eejit that would be named because he would be the first one seen or the last one heard. So Hector accumulated a lot of silly black marks against him, which individually were piddling complaints, but together they built up. If we were sneaking out of the Rec. Hall after hours, Hector would be the one caught. If the lads were messing in their bedrooms giving a wedgie to another lad,

Hector would be the one found with the jocks in his hand. And to his credit he always put his hands up and admitted the transgressions. One particular tutor didn't like Hector. That man did his damnedest to reject Hector. It took him all of five months, but he eventually got the hanging noose he needed.

Hector used to drive a green Toyota Corolla. It brought us to many a magic place when we needed to get out of the claustrophobic enclosure. We would go to Thurles and Holycross. We used to drive out to the Devil's Bit and climb it regularly as the evenings started to lengthen just to keep ourselves sane from the closed-in cabin fever that could envelop you inside. It was our carriage to freedom at night. However, it was also to be the instrument to Hector's departure from the Gardaí. We didn't get much money when we were trainee Gardaí, something like £35 per week. Because we were provided with our upkeep and lodgings, that was what was left of our entitlement. You wouldn't have much change left at the end of the week by the time you'd have a few snacks and drinks. As a consequence Hector allowed his car tax to run out. He was saving to renew it. It would take him a couple of weeks. In the meantime he parked his car in the grounds of the college and decided, as he was a trainee Garda, that he shouldn't drive it on a public road — more sensible than most people who believe there's a two-week grace period between renewal of car tax discs. And generally there is leeway given to people in this regard. But not to Hector.

The tutor saw the out-of-date tax disc and wrote one of those dreaded reports. It shot up through the ranks and another investigation was instigated. It was to be the straw that broke the camel's back when added to Hector's other misdemeanours. The tutor hanged him out to dry. Hector felt compelled to resign. Meanwhile the rest of us were

cautioned that as Gardaí our actions must be above reproach. What did Hector expect, we were told. He expected humanity. Instead he was cast out like a dog and given no chance to defend himself.

It was becoming increasingly obvious that even though our legal studies classes informed us that there was an innocence until proven guilty presumption in the law, we ourselves were not given the same rights. Out of the 63 pupils that started that April 1992, seven were to leave for various reasons, including personal ones, before we were sworn in as Gardaí. I myself clung on by the skin of my teeth.

5

We mastered the drill eventually and our group was considered good enough to perform for phase v's graduation, who were themselves useless. We practised and practised and gave a terrific performance on the day, that is, when the public was around, though earlier in the day we had had an inspection from the commissioner himself that didn't go quite so well.

Immaculately turned out, with gleaming uniforms and spanking shiny shoes, we lined up for the commissioner. This was his first contact with our gang and we were told to make a good impression. In fairness we had put the effort in and we looked stunning that morning when we marched in perfect formation out on to the square. We looked stunning while the commissioner was inspecting the phase v's. We looked stunning as he walked up and down through the ranks of the phase III's. But there was no accounting for Mother Nature. Just as the master of ceremonies approached me on that beautiful morning, a pigeon, of all things, flew over my head and shit on me. It dribbled on my

hat, down the front of my tunic and skirt, and a final plop landed right on my glistening brogues. What could I do but look the man straight in the eye, smile and say, 'I had an accident, sir.' Even he melted into jelly at that. 'I suppose you better go and clean yourself up so,' he said, smirking, and good-humouredly dismissed the whole troop.

Someone told me that day that if a bird picks you out specifically, it is deemed to be good luck. Where did that come from, I wondered. It did exactly the opposite for me. During phase I, ironically, aside from the swimming everything else went swimmingly. I passed my exams with flying colours and was looking forward to a two-week holiday, after which for the next six months we would be out there on the streets, in uniform, shoulder to shoulder with the real Gardaí, though we would have no powers ourselves. Three months were to be spent with one tutor Garda on a unit in a station and the following three months would be one or two-week intervals in specialist units. I was assigned to Blackrock Garda station in Dublin. We were finally flying the nest.

Friday, 4 September 1992, was our final day of phase I. How do I remember the date? Because Saturday, 5 September 1992, is a date that will be forever imprinted in my brain. Joe Murphy, John Whelan (Bogie) and Pat Buckley (Basher), three fellow classmates, had planned a holiday on the Shannon for their two-week sojourn. As they were not to pick up their boat until the Saturday, and as I lived not too far from their pick-up point, I invited them to stay in my house in Belmont on the Friday and I would drive them there the following morning. Majella was to stay with me as well. We were all in high spirits and went out for the night. We ended up in a pub in Cloghan and enjoyed the craic. Joe was a wonderful singer. He knew the

words of songs that hadn't been heard for generations. It was a good night.

On Saturday we had a leisurely morning, took our time with the breakfast and around two o'clock in the afternoon I rallied the boys and told them I would bring them on their way. I begged my mother for the brand new Toyota Land Cruiser. It was only six weeks old and she wasn't inclined to give it to me, but eventually conceded to my unceasing requests. My 9-year-old sister Edel pleaded to come too because she was enjoying the company, but I refused to take her and she ran back indoors crying, thinking I was the worst sister in the world. In hindsight, there must have been someone looking down on her that day.

I drove, and Majella and John were sitting in the front with me. The two other boys Joe and Pat were still tired so they lay down on the floor of the jeep at the back and fell asleep. We got on to the bypass at Athlone and were heading towards the bridge over the River Shannon. There was a mini in front of me so I did an overtake. What happened after that is the most inexplicable and devastating few moments of my life. I felt the steering wheel pull, the jeep started dancing on its wheels, right wheels, left wheels, right wheels, left wheels. I was losing control. I think I let a roar out of me, 'We're gone.' I could see us going over on to the right-hand side of the dual carriageway towards oncoming traffic. I pulled the wheel to the left. The next thing I knew we were rolling across the road. The jeep spun right around five times. I counted them as though it was in slow motion and with each turn I remember distinctly thinking, oh no, I'm still alive. I can still feel that instant of gripping realisation, with my head banging the road at every turn, that this was going to be gruesome and I was responsible.

We had slid right across the road with the jeep on its right

side, all the way over to the left-hand-side grass verge. I was pulled out of the jeep and laid down on the grass. In utter shocked silence and every second like an eternity, I took in all the commotion. Ambulance lights, lots of people, there seemed to be a whole world-going on around me that I couldn't connect with. I tried to get up and someone pushed me back down and told me not to move. My whole body was numb. I couldn't feel a thing. I just felt this great weight of sadness in my heart and I wanted to be dead.

Majella was pacing up and down the road clinging to a jacket. 'The lads are all right T [that's what she called me]. Joe and Basher are fine. Bogie has a cut on the side. I think I broke a finger. We're fine. We'll be all right. We're all right T.' I could sense there was more I wasn't being told. More lights, a fire brigade. I heard someone say, 'It's a six foot drop. They'll have to cut them out.' I couldn't breathe. I couldn't talk. What's going on? I tried to say, but there was no one around me then. Their attention was elsewhere. Majella came back to me. 'The mini, T. You hit the mini and it's gone into the river. There's three people in it and it looks like they have to cut them out.'

Oh God, oh God, please let them be alive! The blood drained from my veins and my heart felt the size of my body with its thump, thump, thump. My head shrank into a panicked, scared zombie state. Oh dear God alive, I silently cried inside, please let me die.

I was brought by ambulance to Portiuncula Hospital in Ballinasloe. I was trollied into emergency and as I looked up I saw my Mammy. She just held my hand. I couldn't say a word because all life within me was gone. I wanted Mammy to keep holding my hand and never let go. And that's just what she did.

In the theatre I was put under full anaesthetic to scrape out all the tar, glass and grit that was in my head. That night

while the nurse was doing her rounds, I recall her getting into a state of panic as she was taking my pulse. I heard her run out into the corridor and call a doctor. I remember that while the doctor was checking my pulse I wanted to die, glad that he wasn't getting a reading. I remember thinking, you'd better let him know you're alive, and making a fist with my hand. 'You gave us a right scare last night, Mary,' he said the next morning doing his rounds. I gave myself a worse scare by waking up.

Not one solitary word passed my lips for seven days after the accident. I was in a complete trance of horror. The woman driver of the mini passed by my ward and looked in without speaking several times during my two-day stay in the hospital. If I had had a gun I would have shot myself. Things just went from bad to worse. It turned out the driver had been carrying her elderly aunt and uncle as passengers. First I heard they had to be rushed to Dublin, their injuries were so bad. Three days later, when I was at home, the news came through that the man had died.

If it is possible to freeze time in an immeasurably sad moment, that is exactly what happened to me for a long time after the accident. I didn't believe I had the right to be alive. My head was in some dark, ugly, weighted dimension in space that was too monstrous to overcome. I couldn't go to the man's funeral because shame devoured me. My brother Arthur went instead and extended my sympathies. Arthur told me the man's family were nice to him and understood it was an accident. For me, it was worse that they were such nice people. I shrivelled up in a little tiny corner of my bed for days without the courage to come out and even face my family. Dealing with my third death in one year, I began to think that anything I touched was jinxed. Hector, my best friend, was going through the turmoil of being thrown out of the Gardaí, and I had just

killed a man. It was a terrible, terrible time.

Throughout a lifetime we're lucky if during the lowest ebb there is that one word of encouragement given by a trusted person. It can make the difference between falling off the cliff or being brave enough to stay fighting in the storm. I got those words from my father. He opened the door of my bedroom one morning and simply said, 'You haven't died a dark winter's night yet, Mary, and I'm not going to let you die now.' Those were the words that triggered me back to life. Those were the words I kept having to repeat to myself over and over again for the next nine months to empower myself against the crap that was flung at me from the Garda Síochána. Those were the words that shielded my heart from the heartless and inhuman manner with which I discovered the Gardaí treat their own when their own do wrong.

6

I was to start as a student Garda in Blackrock Garda station on 24 September 1992, just over two weeks after my accident. Everyone kept telling me I had to remain strong. 'Don't lie down under it, Mary, and everything will be fine. After all, the traffic accident was a private affair and shouldn't have anything to do with your job.'

Meanwhile, the rumour machine had started to spin. She wasn't insured. She was driving dangerously. She killed a man. She's out of the job for sure. The national newspapers got a hold of it and the *Irish Press* ran a particularly damning story calling for a full investigation into the collision that caused a man's death in 'the early hours of the morning'. A senior Garda spokesperson said it's quite possible the incident will be investigated even more thoroughly because a trainee Garda was involved.

I walked through the door of Blackrock station, my head half shaved with a big gash on it not yet healed, afraid and extremely under-confident but holding my head up. I knew straight away from their glances that they all saw the great

dirty scab on my head. They all thought I was a dead woman walking in regard to my career in the Gardaí and none of them, not one, was going to pay 'the tainted one' any heed because she wouldn't be hanging around for too long. I wanted to run out of that room as quickly as I had gone in, but I couldn't. They were the most inhospitable, bad-mannered people I have ever come across. Three weeks beforehand, my cheeky charming self would have broken the ice with some joke. That day I was the broken one, my heart was in shattered pieces and it didn't look like it was going to be glued together by this shower. Not one person mentioned my accident, not my tutor, not my unit, my training sergeant or even my classmates. That depressive isolation was horrendous. Looking back on it now I'm wondering why I stayed around and I still can't answer that.

I met my tutor for the first time. 'I'm fed up with students,' was his first remark. How was I to deal with that, and for twelve weeks? More often than not, he wouldn't bring me on calls and left me hanging around the station a lot.

I thought I might get some scratch of humanity from the female members. I got scratches all right! They could be fiercely territorial about their patch. When I asked one of them to teach me how to use the console (the radio system that communicated between the station and members on the beat or in the cars around the city), she replied that I was 'only a civilian' and therefore 'not entitled to be shown'.

You would imagine that in a dominion which was male dominated there would be a lot of female support. It is the paradox of the oestrogen-driven race. If there is another woman around, that spells competition, which in turn demands that they be blasted out of the water before they get a chance to take a foothold. The boys win out every time, and with an amusing cat fight to watch to boot. This tigress had nothing to fear from me. I wasn't particularly

enamoured by her boys anyway, thanks very much.

When I went on the beat with one of the sergeants and expressed an interest in the liquor licensing laws, he told me he couldn't possibly bring me into a pub after hours to examine the premises or he would be encouraging me to commit a crime by my presence there. The after hours didn't appear to be much of a problem for Gardaí out of uniform!

It's a strange situation to be in, to be in a station wearing a uniform whilst remaining a civilian. You are bang up to date with the law because you have had six months of intensive classes on all the latest Acts, yet your word isn't worth anything in a station. The public generally don't see the distinction between the 'real Garda' and you, yet your own colleagues treat you as a non-entity. You can't even sign a crime report. This phase is supposed to be the practical training ground, on the spot, in the middle of the action, the taking-it-all-in phase, the decider about whether a student is suited for the Gardaí or not. What can you do when you are not even given the chance to answer the phone?

During phase II a student has to work with a tutor but also has to attend classes in Harcourt Square once a week. On my very first assessment I let it be known that my tutor didn't want me. That spelt more trouble for me. Rather than get the support and help I needed, I felt that I was the problem. It was to be a backlash of my accident. I could not be touched on the accident because there was a separate investigation already under way in regard to that. However, the weight of pressure on me would be so great that without proper support I would be sure to break and the problem would be therefore eradicated. There are many members, including myself, who have suffered psychologically from this lack of support.

Hector was shattered when he was asked to resign. I have

seen murderers being treated in a more civil manner than Hector, at the very least being allowed a defence — not Hector. All because of a personality clash, he was dished out with the dirty water and a stain left on his character. One day, he was gone for a long time in his car. I knew there was something wrong. I felt something in my gut. He hadn't said anything, but I knew. I frantically rang his sister, his father, and left messages everywhere for him to contact me. I willed him to be all right. At midnight he finally made contact. He told me that all types of crazy thoughts had gone through his head but that in the depths of his despair he heard my voice calling to him. Now I'm not religious but I am spiritual and I believe I helped another spirit that day. It made up slightly for my feelings of having let my sister down a year before.

From a young age I have always felt the pull of nature. That's how I describe it anyway. I'm not sure exactly what it is, but it's like a life beyond normal life surrounding us all. It's why I thought I wanted to be a nun when I was younger. But I was wrong. It wasn't a God thing. It was more a sixth sense of sorts. Children have it, but most adults lose it. I have it and it particularly comes to the fore around tragedy.

My sister Helen lived in New York with her husband Tom. She loved it there and had just reached the stage in cutthroat New York journalistic quarters where she was able to command her own price for her articles. That was some going for a young Irish girl. She was a vibrant person. It was infectious. In August 1991 she paid for the trip of a lifetime for Edel, my younger sister who was 8 at the time, and my mother. They met her in New York and then went down to Waterford, Long Island Sound, where Tom's parents lived. They had a beach house there that was paradise. Helen taught Edel how to dive during those first sun-filled days they were together.

Meanwhile, I was at home making the dinners, cleaning up for the rest of the family and tending to my grandmother. One of the days while they were away, I was standing at the sink washing the delph when suddenly this phenomenal weakness overcame me. It was like when you get a bad flu where even your bones are sore. An overpowering ache took over every muscle in my body. I was forced to leave the sink, which is not like me because when I start a job I usually stay until the bitter end with it. But these pains got the better of me and I went to bed and lay down. While I was staring at the ceiling wondering what on earth was going on, this mantra started in my head, 'God, give me strength. God, give me strength.' I laughed it off, thinking, you're losing it girl, get a grip on yourself. But no, the chant persisted all the stronger. 'God, give me strength. God, give me strength.' I gave in to it and all the while I felt myself becoming physically weaker and weaker. It went on for an age until eventually I admonished myself. For feck's sake, Mary, what are you at? I forced myself out of the bed and went back doing the rest of the chores. It had lasted two and a half hours.

At 1 o'clock the following morning I was awoken from my sleep by my father at the door. 'Mammy's on the phone,' he said, 'she wants to talk to you. Helen's dead.' I ran to the phone, my heart pounding, and again Ma repeated, 'Helen's dead.' In the instant she said it my first thought was that she was playing a trick on my father to teach him a lesson for not talking to his daughter and for shunning herself and Edel for going to New York against his wishes. I thought it cruel and said to her, 'What are you saying this for, Mammy?' When she said it again, I knew then it was true.

There had been a hurricane forecast and on its way so Helen and Tom had gone out to bring their boat to safety before it hit. The problem was that with the storm brewing,

it threw all their navigation instruments askew and so they were going in the wrong direction. They went further and further out to sea. Hurricane Bob hit with all its ferocity and the boat was hit with hundred-foot waves blasting them from all angles. Earlier they had had to let go of the life raft as it was dragging them too much. Later, when it looked like the boat was about to go down, Tom and Helen tied their life-jackets together and jumped into the hellish sea. Seconds after they jettisoned themselves from their boat it went down. The two of them miraculously rode out the storm. They bobbed up and down in the water for an interminable age and lived to see the quiet after the tornado, with the sun shining down on their faces. A helicopter flew overhead but no one saw them. Car lights from the beach later on shone right into their eyes, but again no one spotted them. 'There's three of us here,' Helen said to Tom in her final hour, 'you, me and Fate.' Fate got the better of my sister after 26 hours in the sea. The battle got too much for her. Tom held on to his wife after she died for another three hours until a fishing vessel finally pulled them out of the water. Tom survived.

It might sound unbelievable but the final hours before Helen's death correspond exactly with the period during which I had been lying on my bed getting weaker and weaker. I have no doubt whatsoever but that my sister was pulling strength from me across the ocean in her last breaths. They reckon dolphins can communicate from one side of the world to the other. We're supposed to be the higher intelligence, so why can't we too? I often wondered if I hadn't admonished myself that day and stayed in the bed longer, could I have given more to Helen. Could I have pulled her through? It's a question that will never be answered now. So helping Hector compensated a little.

7

I was depressed during that initial twelve weeks of phase II, or at the very least completely strung out on sadness — understandable after all I had been through. I should have taken a month off, gathered myself, gone for long country walks and breathed in lots of fresh air. But I didn't. I didn't want to let anyone else down. I didn't want to be a failure yet again. My tutor did not help matters. He continued to ignore me despite any effort on my part to communicate with him and he wrote bad report after bad report about me. I had no comeback when they told me I was the problem, the one with no spunk, no ability to push myself. I wasn't showing any initiative. Talk about trampling you down when you're in need of encouragement!

But life goes on, and somehow even after a tragedy something will happen to lift those dark clouds. The second three months of phase II entailed working two-week stints in specialist units within the Gardaí and a social placement. It would be the social placement that would be my

salvation. I had to spend two weeks helping out in St John of God's in Dun Laoghaire. From the moment the door opened I loved it. There are people of all age groups with several degrees of handicap residing there. When you see those less fortunate than yourself but much happier with their lot, it can be just the kick in the butt that's needed to bolster up a dying spirit. And that's exactly what it did for me. I discovered I wasn't the useless bit of nothing I was made to feel. I was a damn good communicator, even with severely autistic children. I laughed and had more fun in those ten days than it seemed like I had had in an eternity. It was just the thing to get me out of myself. I was getting fed up with melancholy anyway.

Next up I worked with the Drugs Unit in Dun Laoghaire where I was finally shown a decent bit of police work. The Drugs Unit is an active bunch of plain clothes Gardaí who deal specifically with the drug problem in their area. Each division in the DMA (Dublin Metropolitan Area) and country has its own drugs unit and there is also a Garda National Drugs Unit (GNDU) that oversees and interacts with the divisional units. In the case of DMA East the areas covered would be that of Bray, Dun Laoghaire, Blackrock, Dundrum, Stepaside and Dalkey. Dun Laoghaire had one of the highest statistics of heroin addiction in the country at the time I was there. The Gardaí chosen for this work would generally be very eager to eradicate the drug problem or at least help contain it. It's a difficult job and with meagre resources can be next to impossible, not to mention frustrating for those trying to tackle it. Priorities can change I learned, depending on political agendas and money. The unit might have their sights set on a dealer, for example, but because of lack of manpower or no overtime sanctioned it might have to let the opportunity pass. There's many a dilemma in this type of police work. Do you

go after the dealer, or the druggie who's a victim but ends
up partaking of a life of crime to feed a habit? Do you
concentrate on the big sharks and ignore the little sharks?
Do you prosecute the rich kids who are experimenting with
cannabis and not likely to die from a couple of pot parties,
or give your time to 13-year-old girls who are prostituting
themselves for the next fix while their babies are crawling
through syringe-strewn living rooms?

This was an eye-opener for the fresh-faced country lass
who never really had to think much about drugs before. I
had seen drugs in my time. I had been offered them, but I
had never had the inclination to try them. I knew my
capacity for devilment when I had alcohol in my system. I
suppose I was always afraid that I would let rip altogether if
I ever took drugs. I had never felt the desire to let myself get
totally out of control. When I worked in Butlin's as a
barmaid for a summer a few years before, drugs were rife.
In my innocence I used to laugh at the paranoias drugs
would induce in my friends, like the time one of them just
would not walk home on the footpath. Oh no, up on the
bonnets, roofs and boots of cars for her. All along the line
of parked cars she trod, petrified to come down to the
ground for fear the crocodiles would eat her alive. I never
wanted that. There are enough barracudas out there in the
real world without creating more for myself, I thought. So
I could easily pass up drugs at parties; but neither did it
particularly bother me that other people took them. This
stint in the Drugs Unit was the first time I actually thought
about drugs as a vice.

It was also the first time I went 'under cover', spying on
deals. You know, all your life you are reared on *Kojak*,
Colombo, Starsky and Hutch and the like. That first time I
was in plainclothes with a radio in my pocket on our own
secret channel following a known druggie, I got a great

buzz. It was just like I was in an episode of *Hawaii Five O*. I didn't even know what I was supposed to be looking out for. Here was I walking down the main street of Bray, looking like everyone else but with the smug self-important thought, if you only knew what I'm really doing. I met one of the guys I trained with and gave the silent look signal. I'm on the job here. Don't talk to me or you could blow my cover. There's a kind of fear adrenaline rushing through the blood. Can't let this person out of my sights. What's around the next corner? Will he cop that I'm following him, and if he does will he pull out a gun and kill me? Such were the exaggerated thoughts of a redneck recruit playing private investigator. I saw him meeting with another dealer and witnessed the transfer of money between them. I radioed in the find and before I knew it the real members of the unit arrived from nowhere. The druggie is searched and then arrested for possession of an illegal substance. Hey, I'm cool, man! This is fantastic stuff. Welcome to the family, Mary. You've had your initiation. You've witnessed and been a part of your first arrest. Sure why would I need drugs when I had this?

Next stop was the Collator's Office. It was a hell of a lot quieter and a behind-the-scenes kind of office. There is no contact with the public here. Before the PULSE computer era, which is relatively new, the Collator's Office was arguably the most important office in the Gardaí. This is the office that collects all intelligence on known criminals. Again, like the Drugs Unit, there is a Collator's Office in every district headquarters in the country. It has a filing card system of all the information collected on deviants by members of the force, uniform, detective, drugs unit, every active member that might discover anything on a criminal. Each bit of intelligence is relayed to the collator who attaches it to a file. Files of criminals would be kept in their

home districts. What this means is that if I arrest Joe Bloggs from Killarney in Blackrock, Dublin, for an offence, I would ring up the collator in Killarney to find out Joe Bloggs's past form. If there was a warrant for him Killarney should know about it. They would generally have a good description, perhaps even a picture of him, so I would know I had the right person in custody and that he had given a correct name. I could also find out if he had a particular *modus operandi* for committing crime, for example does he always wear a balaclava and carry a screwdriver when he robs old women; has he an alias, a tattoo, a nickname, a girlfriend; does he live with his mother; who are his friends? Everyday, the Central Control Unit would send out a telex to all the stations, reports on headline incidents, major crimes and the full prisoners' list, i.e. all prisoners who had been taken into custody during the previous 24 hours. In the Collator's Office you would go down through this list and update your information on any of your constituents who might appear on it. It's a good system and with committed collators it works well. It's a crucial database for keeping tabs on criminal activity.

That's what I did while I was there. I copied the intelligence on to these cards and double-checked the prisoners' list. There was also at that time the BRS system, the old computer system on which all crime reports, offenders, convictions and the National Vehicle File were accessible. I was privy to some information that astounded me, like who the reprobates were in the area and what their daily routine might be. I was looking up registration plates of cars that were 'dodgy' for various reasons, for example, which of them might be kerb crawlers cruising for prostitutes or which of them might be linked to armed robbery. I was discovering for the first time that being a member of the Garda Síochána had a lot more to it than

signing passports or dole forms. It put you in a position where you could lay your hands on powerful information and check people out. I could have fun here, I thought, and I did.

I looked up all my home towns because we had moved house quite a bit growing up. My Da thought it healthy not to stagnate in one place for too long. 'Be adventurous', he used to say. So I was conceived in Grange, Co. Kildare, and born in Trim Maternity Hospital, Co. Meath. We lived outside Trim until I was 15, when we moved to Cloghan, Co. Offaly. My father then built in Strawberry Hill, Belmont, a year later, and a year after that we moved into the big house across the road. Rather than be travellers who settled, we were the settlers who travelled. I think my father was slowly making his way back down to Galway where he himself had been born. So I had a lot of towns to look up and a lot of revelations in the looking. There was more to my neighbours than met the eye. Mary was gradually losing her rose-tinted glass view of the world around her.

The District Detective Unit (DDU) got their hands on me next. This is the plainclothes unit that deals with anything that might amount to a bit of speed or glory and most definitely not with humdrum police work. No traffic accidents or small time crime here, thank you very much. The pace was stepped up in an instant. The first time we responded to an 'intruders on' call I nearly wet myself. The call came over the radio from Control: 'Intruders on, any car in the area.' The foot kicked down on the accelerator. I was nearly thrown out the back window of the unmarked car. The blue light was pulled out of the glove compartment and slung up on the roof. The red traffic lights were ignored. Jesus, what's this all about? I thought. I'm going to die tonight. We skidded up on to the footpath outside a big beautiful house in Blackrock. A woman in her nightdress

opened the curtain and pointed to the back of the house. I heard rustling at the side gate and before I could take a breath the two detectives I was with had jumped the gate and were giving chase. I followed meekly, scared to death in the dark, chasing around a garden which backed on to a river, but we lost whatever had made the sound. The uniform guys were there by this time, so we left them to take the report of the burglary from the tearful house owner. I was only back in the car an instant, taking deep breaths to bring my heart rate down, when again over the radio came the voice: 'Pursuit on, heading out towards Blackrock.' Holding on to the side door for dear life, the driver made a handbrake turn. My stomach's contents were churning up with both the nerves and the momentum of this sudden increase in velocity. I was afraid to ask what was happening. 'Joy riders, Mary,' I was told from the front. They obviously sensed my fear. 'There's the bastards,' I heard as we drew up to a red light and stopped this time. A huge silver Merc jerked to a halt right beside us. Four scrawny, hard-looking children pulled the window down and started gesturing obscenities in our direction. Their driver revved up the car, daring us to give chase, the look of fatalistic excitement on their faces. The adrenaline was high in our car as well. They took off in a flash and, boy, did we give chase. The testosterone level in our car had skyrocketed. I was in the back seat praying for my life. Holy Christ, what planet am I on now?

There were eight patrol cars giving chase that night, all getting in on the action. Of course, officially it's not called a chase and we definitely didn't go over the speed limit! The uniform car that was damaged had been deliberately crashed into by the 'gougers'. 'Isn't that right, Mary?' 'Of course, boys, whatever you say.' There was no arrest that night as the joy riders had abandoned their car in an

industrial estate and got away from us. What there was, though, was a crashed patrol car, a bashed-up Merc, a lot of geed-up police who had just enjoyed their 'climax' for the night and a battered brain that was me. I'm alive. I survived. It was a high. It was fear. It was orgasmic. This Gardaí is dangerously brilliant, I thought. I had my first good sleep in months when I got home that night.

8

Not every day is as exhilarating, but most detective work in fact involves investigating and it is extremely interesting. While I was there a guy with a sawn-off shotgun had robbed McDonald's. I accompanied the DOs (detective officers) to the scene of the crime. Within ten minutes we had a growing picture of the suspect. Having talked with five witnesses we knew we were looking for a 6 foot 3 short guy who had shoulder-length red to black hair yet bald, white to Asian complexion, a stubby, lean athletic man wearing khakis, denims and shorts and aged between 12 and 50! The perceptions of the human eye under shock amazed me and what's more, they were all adamant they could identify the culprit if caught.

We looked at the videotape of the robbery, which was recorded excellently by a security camera. It was played back in ultra slow motion. Everyone was watching it to see if they could recognise the perpetrator of the crime. I was more fascinated watching the reactions of the people in the queue. There were about fourteen people in the queue

waiting to be served. There's obviously a commotion at the door because all the heads turn in that direction simultaneously. You can see a man carrying a gun run up alongside the people in the queue, jump over the counter, hold the gun to the attendant's chin and grab the money in the till. He then jumped back over the counter and ran down alongside the people in the queue again and straight out the door. That's what happened, but did anyone scream? Did anyone's jaw drop open? Did anyone throw their hands up in disbelief? Did anyone's eyes get wider? Did anyone faint with the shock? Did anyone try and stop the man? Not a bit of it! The 28 eyes looked towards the door, followed the man up to the counter, followed him right back to the door again, and not one expression on their faces changed. They could have been watching a boring tennis match for what their faces gave away. I found this hilarious but it got me thinking. What if I was in a bank while it was being robbed? Would I do the same? Would I just not react which wouldn't look good if it was then discovered I was a Garda? Was there an expectation of heroics from me now? This wasn't just a two-bit job I was in. This was going to mean a lifestyle change. When you are sworn in you have the powers of a Garda 24 hours of the day. My father was granted his wish for a vocation for his daughter after all. Now you might laugh but ever since that day whenever I'm in a bank, a post office, a bus or anywhere that I have to queue for something, my eyes are scanning the place for possible obstructions for a robber. Six-foot pot plants, detachable chairs, poles, pictures, paper-weights, ropes, chains — they're all possible weapons to trip up a robber. In my head they are but would I have the courage or react quickly enough to do anything? Would I be stupid to even try and maybe get shot or get someone else shot in the process? Thankfully I've never been tested yet!

So that was the DDU. They were still investigating that robbery when I left and moved on to the Divisional Office in Dun Laoghaire for the next two weeks, and for the two weeks after that I was in the District Office in Blackrock, a complete change yet again. The Divisional Office is the administrative headquarters for the division headed by the chief superintendent. The District Office covering Blackrock and Dundrum is managed by the superintendent.

There are reports involved in almost everything a Garda does, be it as simple as doing a file for court, applying for clearance for a visa for someone, replying to an allegation of being late for work or worse. For every report that a Garda writes they must be followed through an ordered chain of command. A Garda writes directly to a sergeant, who forwards it to an inspector, through to a superintendent and, depending on the nature of the report, it may see its way up to the chief superintendent. Then if it was a criminal file that needed sanction for prosecution it would make its way to the DPP's office (Director of Public Prosecutions) and come all the way back down again. It might, and usually does, have to go through this epic journey several times before it's done and dusted. There are mountains and mountains of paper in files and reports in the Gardaí and books to locate every page of it. There are 'received at, time and date' books and 'sent to, time and date' books. Everything is recorded with precision so nothing should get lost and everyone is accountable. That's the theory anyway. So for four weeks I was swamped in paper, filing.

Community policing in the guise of Mike Somers grabbed a hold of me after that. This was my first real time out on the beat and it felt odd just walking up and down the streets. There didn't seem to be any purpose. People are

constantly calling on the Minister for Justice to get more Gardaí out on the streets, yet I was here and Blackrock was very quiet. I really didn't see how my presence was instilling a sense of safety in the sleepy village. I did succeed though in learning the Garda walk quite well during that time. It takes a bit of getting used to, to get it just right. There's an art in it, you know. I had to imagine being my grandfather to get it just so. Granddad had a great walk. Stand tall, chest out, slight tilt of the head, hands clasped behind your back. Pretend you're a king or a queen surveying the masses. Slow graceful steps. Slower. Three steps forward. Pause. Roll on your heels, look around you. Pensive countenance. One, two, three, four, five. Another pause. One step back and then three more steps forward. Tip the cap. Good morning, miss little old rich fur-lined coated lady of Blackrock. Remember, with a smile!

I had a headmaster, Mr Higgins, in St Saran's School, Ferbane. We used to call him 'creep' because he had a habit of creeping round the corner when we'd be up to a bit of roguery but also because he had the same pair of shoes since time began and they still squeaked as if they were brand new. He was the master of 'the walk'. He taught me English with a monotone. Yeats, Shakespeare, Patrick Pearse and Dickens were all taught in a dull lifeless drone, except for that squeak. Three steps forward, two steps back, squeak. 'Cast a cold eye on life. Horseman, pass by.' Squeak. 'It was the best of times, it was the worst of times.' Squeak. 'And me father played the melodeon.' Squeak. Here, as I was walking the beat in Blackrock, I heard my own shoes squeak. I determined there and then to buy a pair of Hush Puppies. There'd be no squeak for me if I could help it.

Mike was the first Garda I heard use the word 'hawk'. 'We'll hawk a cup of coffee here,' he'd say to me. We got lots of cups of coffee and lots of doughnuts and lots of plates of

chips just because we were Community Police. Wearing that uniform appeared to be a mighty incentive for benevolence. Fellow classmates alerted me to the freebies available to me now. 'Of course you can go on the buses and get into discos for nothing. Just flash your notebook, you're a student Garda now.' And it was then that I remembered a local Garda at home. He had 50 acres bought and rented around the area. He ran a great farm but amazingly he never possessed a tractor, a trailer, a baler, not even a topper; yet that farm was ship-shape and the envy of other struggling farmers. Sure, why would he buy machinery when the good folk of Cloghan were just so generous? Of course you'd have to give the local Garda your baler on a beautiful summer's day when he asked. Isn't it always good to be on the right side of the local constabulary? Mightn't you need them one day?

So that was the second part of my phase II training. All the while I was still attending classes every week. They had a dilemma on their hands now, though. They didn't reckon on there being good reports on student Garda Mary T. O'Connor. That threw a spanner in the works. All the specialist units had given me glowing reports, and why wouldn't they? Just because I had had a bad accident didn't mean I was a bad person.

Good reports, bad reports, which one outweighs the other? To stay in the job and go on to phase III? To be thrown out altogether? To stay in but be held back six months and have to repeat phase II again and then be thrown out? Every week I hung on a thread. It wore me down, the not knowing.

Meanwhile throughout phase II there were all kinds of investigations continuing into the accident. Athlone Garda station had their file. The insurance companies had more files and Templemore were keeping close tabs on them all.

There were multiple statements taken, but no statement could change the outcome of what had happened. The death of that man still haunts me. Yet in all the recounting of the tale and the nightmares attached to it, I still don't know precisely what caused the jeep to dance the way it did. I can still feel that out-of-control sensation vividly.

A file was sent to the Director of Public Prosecutions to consider what charge to bring against me. I was learning a lot about how to investigate a road traffic accident — from the wrong side. Eventually, they did come up with a charge and I was to be summonsed to court for careless driving.

9

Although the powers that be tried their damnedest to get rid of me, they didn't succeed. The higher boys of Templemore wanted their pound of flesh, so I was summoned back to the homestead for phase III. It was difficult. We had had our first taste of freedom and I couldn't believe the changes in some of my classmates whom I hadn't seen in six months. They came back to Templemore old wise men, gung-ho, buzzing and full of the 'them and us' mentality, 'them' being the 'gougers' that all civvies had the potential of becoming, and 'us' being the untouchable family that were the Gardaí. Some were like pit-bull terriers dying for their day of release when the muzzle could be taken off and they could make their own arrests. They had smelt the blood and couldn't wait for their time. The six months out had intensified their desire to be Gardaí — fast cars, chases, after hours drinking, free discos. Where else would you get it? They had relished every minute of strutting their stuff in uniform playing real Gardaí during phase II. They had only twelve more weeks

to tolerate in the madhouse and keep the head down, then they would be free. Power would be theirs. I lamented for any member of the public that would have to deal with these bucks.

Of course, there were a few of us who were simply overawed by what we had seen in the stations and were still unsure as to whether, when the day came, we could handle it on the beat on our own, or not. I had a lot of doubts. I was extremely shy growing up. I would blush to high heaven at even the slightest look in my direction. Michael Jennings, a classmate who sat behind me in school, used to have great fun whenever a teacher asked me a question. 'Mary, your neck is a lovely crimson colour. Oh look, your ears are red now. Will I get the fire extinguisher?' I was bashful all through my childhood and the thought of patrolling a community, or having to tell someone off or admonish them for wrongdoing terrified me. Having to approach a fight on the street and sort it out, I have to admit, was a fearful prospect. But I couldn't let on I had any reservations about my career choice, not when I had to contend with justifying my presence in the college every day.

Every day I was hauled up to Superintendent Ludlow's office. 'Well, Mary, why should we keep you in the job?' Why indeed, Superintendent, I often thought of saying but didn't. I played the game, him questioning me, breaking me down daily, me smiling back at him but not trusting a word he said. I knew he was just biding his time until the court case came up. He was awaiting the outcome of that before he would make a decision on whether to retain me in the job or not. It was a game I was unused to as I had always been a straight talker. In any other college I had been in, the tutors went out of their way to encourage their students and help them in any way they could through a struggle.

Not in Templemore. Here, they were just waiting for students to show any degree of weakness so they could pounce on them even more and put the pressure right on. It was a game that was wearing me down, not least because though all my classmates had a good idea of what was going on, they preferred to ostracise me rather than help me through it.

Did you ever spy a blue-black clouded sky the instant before it bursts its belly when there's a crisp clarity in the air? Well sometimes when there's a sad shroud hovering over your head it can help you to see things more clearly. That's exactly what happened to me. I discovered that it is true what is written, that when the chips are down and trouble is around that the real character of people comes out, and true friends are revealed. Slowly the realisation came to me that I had absolutely nothing in common with the people I was training with except the fact that I was training with them. Maybe it was because I was older than most of my classmates, or maybe I was looking at this Garda business too much like a civilian. I got no support from my fellow students, not even the ones who had been in the accident with me. I had had a traffic accident, but in the eyes of the trainers it was blown up into gargantuan proportions and I was made to feel like a criminal. My classmates, I felt, did not want to associate with the criminal. The pack gathered force and I felt like an outsider.

Aside, that is, from the knight in shining armour who stormed into my world on his trusty steer in the shape of Garda Tom Comerford, one of my tutors. The first day he sauntered into our class to give us a lecture on social studies, I knew by the devilish smile in his eyes that he was completely different to the other robotic mules that towed the line in the hope of advancement. Here was your true rebel who questioned the system and I felt a connection

with him instantly. His first class was on the different thought processes of the mind. 'What are they?' he asked. No one replied. 'Memory, logic, spontaneous nerve reaction, learned reaction? Anything else?' 'What about fantasy?' I replied. 'What about when your mind uncontrollably drifts off into erotic fantasies?' He turned to look where the response came from and caught my tongue in cheek, bold eye with a sparkle from his own. 'Very good,' he said and wrote 'imagination' on the blackboard but spelt it wrong. And I'd swear if he hadn't been so tanned there was a light flush in the jowls.

'Load of shit, that lecture', was the reaction of the boys when Tom walked out the door. What are we doing social studies for, they wanted to know. 'It has no bearing on our job. It's a waste of time.' Of course, boys, why would a Garda want to be educated on the structure of society and its influences? You're right, that surely doesn't make sense!

The passing flirtatious banter between Tom and me continued for a couple of weeks. Each meeting on the corridor was a sparring delight of smut and wit and smiles. It was a welcome diversion from the seriousness of the impending court case and how no one dared mention it. Tom was a live-in tutor. He had sleeping quarters just like ours but in a different block across the square, so he was around at nights as well as during the day. It was inevitable we would bump into each other regularly. One evening he plonked himself down beside me in the tuck shop with a cup of tea. 'Anyone in your phase in trouble?' he asked. As if you didn't know, I thought. 'I'm the black sheep of this family, but you knew that already, didn't you?' I replied. We got talking and for the first time I felt I had an ear that was really listening. I liked this man. He made me feel human and he seemed genuinely interested in my plight. And he made me laugh.

Now Polly's pub was literally five steps across the road from the front gates of the college. This was the social hub that bustled every evening with both students and tutors. I used to go in each day purely for their delectable special toasted sandwiches that were like heaven in comparison with the bland tasteless chicken legs of the college canteen. It was there too that I would habitually meet Tom. We would get talking and soon we became pals over a pint or two.

Every Wednesday afternoon was given over to sports. It concentrated mostly on the boys' sports, rugby, football, hurling and the like. There were a few of us who were not very enthusiastic about these team activities so we chose hill walking as our activity. We would go to the Devil's Bit, climb it and have a pint on the way home. One or two of the lecturers came along for the craic, Tom being one of them. After the first couple of weeks most of the others lost interest in the walking, but not myself and Tom. Every Wednesday afternoon we would go wandering around the fairy roads of Templemore. We discovered among our adventures a lovely quaint pub up in the hills in a townland called Kilalea. It didn't look like a pub. It looked more like a normal family home and you had to ring the doorbell to gain admittance. They had three taps, Guinness, Smithwicks and Harp, and nothing but whiskey in the optics, and a welcoming open fire. It was here Tom and I opened up to each other. It was here that we had a warm refuge from the worries of the world. It was on the way home from there one dark starlit night while Tom was pointing out the constellation of Cassiopeia that our lips locked in that first magical kiss. Now I'm sure there was an unwritten code that tutors should not fraternise with the students, but there is no accounting for physical attraction. There was certainly no accounting for the bewitching dust this guy was sprinkling over me.

Tom, nine years older, was in the throes of a separation. Part of the reason he had applied for the academy was to give himself time to think of what he wanted to do. He hadn't planned on falling for me and I hadn't planned on letting him. I had never known the attentions of a man like this before. He literally bowled me over, but the sad part of it was that it all had to be clandestine. We couldn't let the gossip start for both our sakes. But we had great fun.

I took to staying in the college some weekends, and so did he. We'd borrow bikes and go cycling, have Sunday picnics by the river, miles away from everything. We got lost in a wilderness of deep affection and it was a wonderful opening of the heart for me. I had met my soul mate.

'Homewrecker' I heard shouted at me one evening as I entered the tuck shop. The voice was that of another student in a junior phase and in one fell swoop my bubble burst. The enormity of being a third party in the split-up of a family slapped me full force in the face. We tried not to have any contact. We really did, but this man was the only friend I had in that institution. The non-communication tormented me, my court case was coming up and the superintendent was getting on to me more and more about my level of participation. One day I snapped.

The superintendent met me on the corridor. 'Come into my office,' he said. I followed him in. 'You look down, Mary. What's the matter?' 'Nothing, sir,' I replied. I had long since suspected that he was taping our conversations because he was always able to remember verbatim what I had said many visits previously. 'But you don't look at all well, Mary. You know you can trust me.' 'I'm fine,' I said but he just wouldn't let it drop. He went on and on until Mary could take no more. The sadness of my life at that moment overwhelmed me. I was about to go to court for a charge that was connected with the death of a man. I had found

the man I loved but he was married. I was being snubbed by the whole college now for two reasons, and here was this man who was threatening to throw me out every day of the week asking me was I all right.

'No, sir, I'm not all right.' I eventually came right out with it. 'You have treated me with less respect than you'd treat a dog. I have got no support from you or from any other member of the Garda Síochána. You've had me come in here every single day justifying every single minute of my existence in this job and I can't take it any more. Throw me out. I'd be better off if you did. I wouldn't have to put up with this shit. I don't need this job. I know I'm a good person. I don't need to have to prove it to you in my every waking moment. Just get rid of me and be done with it. My brain cannot take this messing any more.' I walked out the door feeling better but also thinking, oh God, this could be the end.

The next day I had my court case. Tom offered to drive me home that evening and to be there in court for me. We took a detour on the way home to Belmont. 'Let's see Clonmacnoise,' said Tom, and we strolled round the monastic ruins of St Ciaran like tomorrow was going to be the day for the guillotine and we had to get it all said right now. Evening went into night and as we sat in the car looking at the stars, Cassiopeia again cast her spell and Tom's kiss transported me into another world. That is, until Mother Nature took a hold and dictated I relieve my bladder.

It was pitch dark as I stepped out of the car and found a wall, behind which I had planned to relieve myself. The wall was about two-foot high, up to my knees, so I stepped up on it and leapt over. I hadn't planned on it being a seven-foot drop on the other side. An excruciating pain shot up through my leg. Jesus, I'm going to faint, and I lay down on

the cold wet grass, overcome by a cold sweat all over my body as I stared at an old Celtic headstone of one Tadgh Claffey. Was I being punished for the bad thoughts of being about to commit a mortal sin? Were the ghosts of the monks of Clonmacnoise displeased with my courtship? Weakly I called for Tom, but the drones of Bob Dylan blaring from the stereo drowned out my shouts. It took an eternity to clamour back up that wall. You gods have a great sense of humour, I thought, giving in to the hilarity of trying to explain my pain, all for the want of a piddle! 'Did you not miss me, darling? Did you not think I was gone a long time?' I quizzed, as I dragged my battered leg back into the car. 'I thought you couldn't find a spot,' says he. 'Oh, I found a spot all right,' I laughed.

My daddy didn't laugh. Of course I didn't tell him exactly what happened. 'You're not going into that court tomorrow limping,' he said. 'I don't care if your ankle is broken. You'll walk up that courtroom tall and straight, and you won't be evoking any sympathy from the judge by having an injury, do you hear me?' I didn't sleep a wink that night. My leg got hotter and hotter through the night, aching in incessant, throbbing pain. I cried for the soreness of it but also for the tenderness of my heart that had to face up to the family of the dead man who had been caught up in an accident I still could not explain.

My Da never once mentioned his six-week-old state-of-the-art crushed Toyota Land Cruiser, unrecognisable after the crash. He was like that, my Da. He knew when his children were beat up inside and words wouldn't help. He wouldn't be one to give a hug or express emotion, but he would be my rock in the sense that I knew that if I came from the blood of this strong man that never ran away from anything in his life, then I too could stand up strong and take what life would throw at me. 'Be honest,' he said.

'You're nothing in this world if you're not honest.'

In the end it was my honesty that got to the judge. No one saw my black ballooned ankle that was tightly bound with bandages and squeezed into my shoe, or how the pulsating pain pounded up my limb as I went to take the stand. The trial lasted four hours in Moate District Court. My counsel suggested I could have hit something on the road that would have caused the pull on the jeep that sent me into a spin. I answered, 'I couldn't recollect that.' I gave the account as I remembered it, that I just didn't know what had happened, but that I thought I had completed the overtake of the mini correctly. There was evidence I had hit the mini when I was coming back in from my overtake. I couldn't deny it. The prosecution tried to suggest I had fallen asleep at the wheel because I had drunk a lot the night before and also that I had been speeding. That I could deny. To my advantage, there was a witness called who was driving behind me who said she had been driving at 50 mph and catching up on me, but that I did slowly come over to hit the mini. Expert road engineers were brought in to suggest there was a dangerous camber on that particular section of the road and that a lot of accidents had occurred there. Everyone was trying to give me an out but I wouldn't take it. I just didn't know what happened so I couldn't in all conscience say I did. It was what saved me.

The *Offaly Independent* ran a full page on the outcome. 'Recalling the evidence, the Judge remarked that it would appear the jeep took up the proper position to overtake. However, he stated, it then moved across, caused the collision and was responsible for the accident. In a civil court, Ms O'Connor must be responsible for the damage involved. However, I must be satisfied, in this court, that the defendant drove without due care and attention', he remarked. He said 'she had two possible defences: the first

was that a gust of wind caused the jeep to wobble, the second being that she struck something on the road. If she had opted for one of these, I would have dismissed the case. However, she was extremely honest in her evidence and gave neither. Nor did she claim that the mini had moved out imperceptibly', he added. Concluding, he said the defendant had been truthful about what had happened, and giving her the benefit of the doubt, he dismissed the charge.

News of my victory spread quickly through the corridors of Templemore, and when I went back to the college that evening all the tutors I met shook my hand and congratulated me. Superintendent Ludlow called me into his office, never mentioned the case and said: 'I was thinking about what you said yesterday, Mary. I was impressed with your gumption and we've decided to keep you on. There'll be no more interrogations.' Welcome back into the flock, O prodigal daughter. To hell with the whole lot of you, I thought. What triumph was there for the man that's dead and buried, and his family?

10

L ife is just one unpredictable capricious caper after another, and just what part we have control over I still don't know. There really is no rhyme or reason to certain events in one's life. Bad things do happen to good people. Shit happens all the time and no one gets a complete smooth ride. Up and down that roller-coaster goes and light-hearted relief is always round the next corner, but only if you're open to it. Those gods above are such comedians, they created us humans in the form of a bundle of contradictions just so that in the throes of sadness some glint of joviality can bring us back to life.

When my grandmother was in her final few days and I was sitting by her bedside, even though with one hand I was holding her frail fingers and with one eye I was looking into the glazed-over eyes of a woman near death, my other eye was reading the effing and blinding and carousing and hooring, the life-filled, thigh-slapping tickles of Roddy Doyle's *The Snapper*, a copy of which I held in my other hand. I must have been chortling aloud because Gran asked

me to read it to her. When I did, to a woman who has never cursed in her life, she got the giggles. At 92 years old she's discovering crass crudity for the first time and she's getting a kick out of it. Now isn't that what living is all about?

In the midst of this cheery recitation, she squeezed my hand, looked me directly in the eye and said, 'I'm happy, Mary. I've said all my prayers a long time ago. Sure what harm can I do now. I'm happy to go.' She had no fear of death but she clung on until the end of that book. Maybe she wanted to amass as many bad words as she could in case the devil got in her path on the way up, or maybe she just knew the importance of a good chuckle even at the worst of times.

Things were not all bad in Templemore. I had my personal trauma, but in the whole scheme of events it was only a minor glitch to the proceedings. Life always goes on, and where there's a crowd of trainee Gardaí there will always be amusement, in bucketfuls.

One of our duties as trainees was to make up a respectable Garda presence for the likes of memorials, Masses and Garda anniversaries, occasions that your normal Joe Soap Garda just would not be bothered going to but would be a public affair. The press would be there and so would the commissioner. Now you couldn't have the journalists thinking that there was apathy amongst the troops for state events, so the fresh-faced recruits were bussed in to fill the void. Rent-a-crowd was what we called ourselves.

The Mass in Knock on 8 May every year was one such occasion. The great coats were unravelled. They were like World War I trench coats but in fairness, though they were heavy and cumbersome, they were windproof and, by God, did you need that in Knock. I never understood why Our Lady chose the breeziest, most windswept, bleakest, most

barren, backward place in the world in which to miraculously appear. You'd have to think all the same that it was a grand boost to the economy of a severely disadvantaged area that such an apparition had occurred!

I knew Knock well. It had many mixed memories for me. We regularly went there with Ma and Da on day trips that were invariably wrought with rows because Helen couldn't bear to have anyone sit within six inches of her in the back seat of the car. There would be Ma and Da and one child, usually Morgan, in the front seat and five kids in the back. Four of us would take up one-half of the back seat, Arthur sitting on my knee, Colm and Patrick squashed beside me. Helen would have the other half to herself and dare anyone cross her line! She was a demon growing up. Any long journey was a nightmare, Helen accusing us of slopping our lollipops 'deliberately on purpose' just to annoy her. We breathed too loud, we sat with slouched shoulders, we didn't hold our bellies in, and every word we uttered was stupid. Our very existence was just such a source of torment to her. Helen, 5 foot 6½, was the size of a woman at the age of 10, and as the eldest she was treated like an adult too. I was the fourth child. Helen was 3 when I was born. Poor Ma, everyone vying for her attentions, but Helen and Patrick, in constant bitter combat, the most. Hetser is what we called Helen. Patrick came up with that because it sounded like heifer and she had a thing about her size, so it hit the exact spot. 'Wherever two or more of you are gathered I shall be there', said the priest in Knock, a vessel for the words of Our Lord. It seemed the O'Connors were better off in singular veneration, for wherever two or more of them were gathered there were tears, deluges of them.

It was on a school excursion to Knock from the Convent of Mercy, Trim, Co. Meath, when I was 14, that for the first

time in my entire life I ever even thought of a curse, never mind let such a monstrosity pass my lips. Maria McKeown and Madeleine Naughton were jeering me for having sat beside the 'swots' on the bus on the way down. They started pushing and prodding me and calling me a 'goody two shoes', and in a powerless weak moment the words, 'Fuck off!' sprang into my head. I only thought of the words. Oh dear God! My whole body flushed with shame and I held my head in my hands and thought, I must go to confession. I was afraid to go in Knock that day for fear of more belittlement from the bully peahens so, instead, I climbed Croagh Patrick in my bare feet on the day of 'The Reek', the last Sunday in July of that year.

That was the first day in my life I was ever proud of myself. I had set myself a challenge, had trained all summer by forcing myself to run barefoot up and down the pebbled avenue to toughen up the soles of my feet, and I did it, with my mother beside me cringing at every tentative step I made. It took me hours but I did it and only one big toe suffered with the loss of a toenail afterwards. The sin of thought (the curse) was avenged and I was pure again. I was happy — until Annemarie Cunningham got her hands on me and brought me on an all-night vigil down to Knock with her mother and a whole busload of pious women from Athlone. Annemarie had an impish mind. I met her in Athlone Regional College when we were studying accountancy together. We were a lethal combination. Those poor lecturers, they hadn't a chance. Whenever the resident Brad Pitt would pass our desk, Annemarie would pretend to go into a swoon at the whiff of his aftershave. 'The brute is wearing Brut,' she'd whisper to me. 'I lovvve Brut.' And she'd feign a silent orgasm behind his back. I could never contain myself and inevitably the class would be disrupted with my convulsions until I'd be compelled to leave. She

was the female equivalent of an adorable rogue and the first one to point out to me, after an all-day fast and we in delusionary devilish humour kneeling on the freezing cold ground doing the Stations of the Cross at midnight in Knock, that priests have willies too. 'Look at him, Mary. He's bulging,' she said. More laughs. We were a disgrace. There could be no redemption after that. I decided to become an atheist. Sure how could I ever be chaste in the eyes of Our Lord ever again now that I was looking at the Pope to see could I catch a glimpse of his willy.

Tears, curses, confessions and willies — that's what Knock meant to me, so I knew in my heart there would have to be some form of entertainment when the busload of trainee Gardaí arrived in the hallowed grounds. And there was. We did our duty in the miserable cold and rain. We marched up the town to the air of 'Hail Queen of Heaven' with due respect; we read the first and second readings reverently and devoutly walked up the aisle with the offertory gifts; we recited the prayers of the faithful; we helped the handicapped receive Holy Communion; and then we went to the pub and got pissed! There was a meal put on for us with trifle for dessert. Most of us had more a pint in mind than a plate of trifle. Not John Holland though. He decided he'd scoff as many of those delicious trifles as was humanly possible. It was only when he tried to load a pint in on top that the stomach objected and up shot John racing into the toilet to vomit. After he had flushed the toilet and looked in the mirror to make sure he looked respectable, he saw that his smile was a bit awry. Where the hell were his front teeth? A plate with four top teeth had gone down the toilet bowl.

John went home for the weekend without his teeth. I met him in the middle of Templemore on the Sunday night and asked him about the teeth. When he smiled there was a

massive gap of nothing in the top half of his jaw. 'Jesus, what happened, John?' 'I went to bite an apple this morning,' says he. 'The plate was obviously supporting the other teeth for years and without it they were weakened.' Two more came out with the bite and he'd swallowed them. He had suffered the curse of Our Lady of Knock, sixfold. He obviously hadn't had a chat with his guardian angel for a while. I couldn't stop laughing.

Tom Comerford was my guardian angel that led me to mischievous distraction away from the shackles of the college's conformity. It was spring going into summer and the tides were turning to brighter days. There was a light-headedness in the air and like the young lambs leaping around the fields we were engaging in bold frolics of our own. We met in the library, on the corridors, in the classrooms, in the handball alley, anywhere we could experience the fix of the tingling, skin-brushing, brief encounters that teased the juices to boiling levels. It was like an addiction. Weekends were the most daring and the most fun. We'd sneak into the visiting superintendent's quarters — he had a nicer bedroom than the rest of us and a double bed! We would investigate all the forbidden rooms that spelt doom if we were caught in them. And it was all so innocent. We were like first-time teenage lovers on a voyage of discovery of each other's bodies, slowly, playfully eking out the pleasures of the flesh. Writing and reciting poetry, we were simply basking in romantic, cloak and dagger bliss — until the day we were caught, that is.

Both of us were studying for exams. Tom was taking the sergeant's exam in May and I had my legal and policing tests to sit to finally gain my badge once and for all. We would always start with great intentions, the theory being that two heads studying together, brain bashing, were better than one. And it was, for all of ten minutes, until the smut

would start and the eyes would make contact. 'C'mon, stop it. We have to get these exams,' I'd say, but the great smirk and gleaming doe eyes would get me. One Sunday we were in the staff room that was generally vacated at the weekend. We were lounging on two armchairs side by side, learning the Judge's Rules, and I decided the only way we would get any study done would be to incorporate a bit of fun. When Tom would get a question right I could choose a spot where his hand could venture on my body, and vice versa. That day he seemed to be asking the most questions or I just happened to be getting the most answers right because he was getting more and more brave about where he wanted my hands to roam. Bit by bit the buttons were coming undone and the fingers were feathering down his chest, below the belly-button. The belt was unbuckled, the zip released and just as my hand wandered lower, the door burst open and in shot the Garda from the guardroom. There was a panic fluster of pages flying, trying to cover up the evidence when, just as quickly as the Garda rushed in, he did an about turn and tore out the door. 'Holy fuck!' I gasped, going into a seizure of nervous laughter, 'do you think he saw anything?' I spent that night in Tom's bed and we vowed to have no more contact for the time being.

Monday went by, Tuesday and Wednesday, and we were beginning to breathe a bit easier about our misdemeanour, fooling ourselves that the Garda couldn't have seen anything; and even if he had, sure he wouldn't report us. We were wrong.

On Thursday, while Tom was in the hall sitting his exams, the call came over the intercom. 'Mary O'Connor to the superintendent's office.' Not again, I thought. Can I get away with nothing? I sat down in the now familiar interrogation chair. 'Mary, I don't know what to do,' the superintendent started. 'Last week I sent a roaring

recommendation to the commissioner about your great attributes and why you should be retained in the job. Now wouldn't my judgment be called in question if I had to send a bad report this week?' His opening stance for some reason gave me great strength. The man was looking for an out. Tom had advised me, 'This job is afraid of women and sex things, Mary. Ask him to make a direct charge, then watch him run scared.'

The superintendent continued that he had received a report from the Garda on the gate. He waited for a reaction from me, but I had learned, through the superintendent himself, not to be too forthcoming with information. This time I was not going to spill the beans at the first hurdle. 'What does the report say?' I calmly asked. He read it to me and, as I thought, the yellow-bellied Garda had made no mention of the penis. He merely said he had caught me in a prohibited part of the building 'sitting very close to' a member of staff.

The superintendent asked: 'Do you realise that Tom is a married man with two children?' 'What are you suggesting, superintendent,' I replied. 'Are you calling my Catholic morals into question? Are you insinuating that the chairs were on top of each other?' I said, bravely eyeballing him. 'Absolutely not, Mary, but I am charging you with being in a prohibited part of the building.' He handed me the formal charge, asked me to sign the receipt and told me the chief wanted to see me too. As I got up to leave he told me, 'I should be more circumspect about my relationship with Garda Comerford.' I had to contain my smile.

I sat outside the chief's office for as long as it took the superintendent to ring him and relay our conversation. The chief simply repeated what the superintendent had said, except he had the authority to caution me in relation to the charge. 'There's no point in going any further with this,

Mary,' he said. 'Consider the incident dealt with.' As I was leaving he also told me to be more circumspect with my dealings with Tom. But just to ensure compliance of the order, by Friday evening Tom was transferred to a station in Dublin, far away from Templemore and its environs, and me.

As it happened, everything Tom and I had studied came up in my exams and I was more prepared than I had previously thought. Fun learning worked after all! I passed with flying colours. All that was left between me and my badge was the solemn ritual of attestation. On 10 June 1993 we each held the Bible in our right hand and swore the declaration 'I, Mary T. O'Connor, swear by Almighty God to conduct my duties without fear, favour, malice or ill will toward any.' An assistant commissioner gravely handed over my lifelong emblem of authority. 'This is to certify that Mary T. O'Connor is a member of An Garda Síochána with the rank of Garda. Signed P. J. Culligan Commissioner.' I was the real thing. I was proud and I was scared. Where to now? I wondered.

The next surprise in store for us all was where we would be stationed. My guess was that I wasn't going to get anywhere near Dublin, or more specifically, near Tom. I was right. My mother didn't care where I went as long as I didn't get Hackballscross. She said she couldn't possibly send me a letter to that address. There were lots of nervous heads in the lecture theatre on Friday morning, hung over from the celebration of having finally made it to full pay. The Cork boys didn't want to go to Dublin. The Dubs didn't want to step one foot into culchie country. No one wanted Store Street due to its reputation for being rough and tough. The married men wanted to be facilitated close to home. Everyone had their own preference. Me? Well, I didn't really care. Hadn't I moved a good bit already in my life? I was

open to offers. The roll call started, as did the oooohhs and aaahhhs and gasps and screams and tears when each person's name and destination was read out. Mary T. O'Connor — an eternal pause — Castleblayney Garda station. Where in the name of God is that? I thought.

11

I took out a map of Ireland and had a scout for this town, Castleblayney, I had never heard of before in the county of Monaghan, the land of free-range eggs, mouth-watering hindquarters of bacon and Kavanagh's *Stony Grey Soil*. That's as much as I knew. Wasn't that bandit country, I thought, within an ass's roar of the border? Arthur, my brother, drove me up. It was a long, windy road from Belmont, Co. Offaly, cutting cross-country all the way, turning off at Milltownpass through the sinking bog road to Killucan, Delvin, Clonmellon and then facing into that twisting pot-holed road from Kells the whole way up to Carrickmacross. A mighty road suddenly opened up after Carrick, then Blayney, and I thought it must be an important town to have a main road like this running into it. Well, we were in and out of the massive Castleblayney and on the road to Monaghan town in a full minute and a half. 'We must have missed most of it', I said to Arthur and he turned the car around for a second attempt. We had overlooked the main street all right. We motored through

the main thoroughfare. In another full minute and a half
we were out the other side of the town and on the road to
Keady, Co. Armagh, Northern Ireland, with my uniform
sitting on the back seat of the car. Now that wouldn't be a
great idea, would it?

About turn again and this time we took a little back road
off the main street and to the left there was an entrance into
what looked like a grand old estate. Over the gates in ornate
cast-iron lettering the sun glistened upon the words 'Hope
Castle'. Seeing those two words was like a ray of sunshine. I
knew in that instant that this town would be my new
beginning. We drove through those gates and it was just like
unlocking the door to a secret garden. Beautiful Lough
Muckno, smiling broadly at us in all its magnificent beauty,
was a huge shimmering lake with a forest island in the
middle of it. I took a liking to this place without having
talked to even a single person. 'This is where I regain myself.'

We eventually found the Garda station. It was a Sunday,
and a particularly quiet one at that, though perhaps this
was Castleblayney in all its glory. The front door of the
station was closed. I knocked. No answer. I knocked again.
Still no answer. On the third rap I heard a gruff male voice
filter out from within. 'Come in, will you. The door's open
if you bother to try.' Entering the station I looked through
the hatch. So this is what the eloquent orator looked like.
We had obviously awoken him from his sleep. This huge
man was lying back on an armchair, his hands crossed
behind his head supporting it. His huge knobbly hob-
nailed boots rested at the end of the stretched-out, crossed
legs on the desk, just like my own father on a Sunday
afternoon at home in front of the fire after the big roast.
With one eye half open he asked, 'Are you all right?' in a
tone that suggested, you better not be wasting my time. 'I'm
the new Garda,' I said. 'What are you doing that side of the

counter then? Come in.' In the time it took me to walk in through the next door, this man was up off his feet with a big smile extending a hand of welcome. He had a warm handshake and the toughened welts on the skin revealed the toils of hard labour. He's a Garda in his spare time, I thought. He must be a farmer too. 'My name's Gerry,' he said. 'I believe we'll be on the same unit.' As he spoke I spied two other curious faces make their way up the corridor. Pat Rafter and John Hobbs nearly tripped over each other to greet me, though in hindsight and knowing the men now it was probably Pat who was bursting to get to shake my hand first. Pat was like a wiry mongrel that was always moving and always willing to please. John, on the other hand, was a far more measured man. He would have hated had he appeared too eager.

Pat had already taken the liberty of organising a place for me to stay for a few days with a couple of teachers while he would be on the look-out for a flat for me. I was starting to feel at home already. We parted their company with the warning that not all the pubs in town were Garda-friendly, went in search of my lodgings and I was to officially start my duties at 6 a.m. the following morning.

Arthur off-loaded me and went on his way as I mulled over that term 'Garda-friendly'. What exactly did he mean by that? I got talking to one of the teachers in the house, Caroline, from Cork. Through the conversation it became clear that she couldn't wait for term to finish and she would be gone. She would never come back to this town teaching again if she could help it, she said. 'Why's that?' I asked. Caroline was a religious education teacher. She had been trained in Mater Dei and though she was teaching in a Catholic school she believed herself that all religions had merit. She wanted to teach the children more in terms of Christianity than staunch Catholicism. Apparently several

meetings of the parents' council of the primary school had been called to question her over her opinions. She had received threats from some of the parents who made it very clear that her position was in jeopardy if she tried any of this 'new-fangled stuff' on their kids. 'You're in a border town now, Mary,' Caroline warned. 'Religion and politics cut right through to the bone here.' Two warnings within one evening. This is very intriguing, I thought, and it somehow triggered a memory of Tania from years ago who had moved into the house across the road from us in Trim.

As we were growing up we had the whole stretch of Breemount Hill to ourselves. Almost a mile long with a limestone quarry in the middle of it that was owned by Roadstone, every couple of weeks there would be a real live explosion that would shake the ground from under you. We had dangerous cliffs, acres of meadows, a massive orchard that was a hundred years past its glory days but we could still see its magnificence, and a three-storey tree house we built from Volkswagen casings. The big chief, young O'Connors, reigned in this land until the day our curiosity was aroused by the invasion of a family with 20 dogs up the road from us.

The howling of the canines brought them to our attention first. We would stop at their front gate and stare in, but the man of the house would shoo us away like we were intruders. 'There's something goin' on up there,' Patrick declared one day. 'We have to get to the root of them people.' They had young kids and that was the lure, playmates right across the road, but their Daddy looked mean. We knew every gap in the hedge around that house because it used to be our own. Even so, no matter which way we tried to get in, be it dewy dawn or darkening dusk, those blasted dogs would get a sniff of us and start their yelping. Out would come the man with his shotgun and as

we tore away we would spy the eyes of two little girls peeking out through the window.

As it panned out, our persistence paid off and the two little girls came in search of us. Their Daddy was away for the day and they toddled over to our backyard as we were milking the cows one evening. 'What are you doing there, mister?' Tania roared with boldness in a Northern accent from the top of the milking parlour pit, and half the clusters came flying off the cows' udders in fright — not a great way to ingratiate yourself initially to a farmer, particularly not my Daddy. She got the look from him, in the midst of the kicking and panic shitting of the animals, and knew to vacate the premises quickly. I ran after her. The mother in me wanted to placate her and tell her my Da's bark was worse than his bite and the little girl in me thought, wow, a girl across the road my age, great! Helen never played with me.

I plodded up the mucky back avenue in my wellington boots and halfway up, sitting casually on top of the garden gate, was Tania with a cigarette hanging out of her mouth. 'Do you want a smoke?' was the introduction. 'No,' I replied and with that the weanling calves, hearing the voice of their feeder, came charging over to the gate and pucked it vigorously for their bucket of milk. Tania toppled from her 'cool as a cucumber' pedestal and both she and the cigarette splattered into a great liquidy lump of dung. Welcome to culchie country, young townie. She baffled me because she didn't do the usual townie thing of running to her Mammy crying about dirtying her clothes. No, this girl picked herself up, wiped the manure off her face, smiled, put out her hand and said, 'Hi, I'm Tania and I'm 9.' I was just gone 10. This was brilliant.

From that moment on there was no getting rid of Tania. She was over every morning as soon as the sun came up and

still there until well after dark. She loved the farm. It was such a contrast to what she had known before and bit by bit, though she was very careful in what she would divulge, she began to trust me and tell me things. They had moved from Belfast and the dogs were for protection, but her Daddy had guns as well, just in case. They wouldn't be there long. One day she told me she had a secret that she would tell me when she knew me better. It took a month — a month of scrapes and falls, bale stacking and chasing cattle, haunted tree-house stories, and promises of everlasting friendship and covenants of silence. Eventually, one night seated in the most secret spot in the hay barn with Bible in hand solemnly swearing never to ever tell, Tania told the tale that had eaten her up for so long.

'My best friend in Belfast was a Protestant,' she whispered, and put her face in her hands. I hung on, saying nothing, waiting with bated breath for the secret. A murder at least for the length of time it took for her to come clean. 'My mother knew but we wouldn't dare tell my Da,' she continued, this time in a more shaky voice with tears coming into her eyes. 'You won't tell, Mary, will you?' 'Won't tell what, Tania?' I asked, completely bemused. 'But she was a Protestant, Mary.' 'So?' I replied. 'But you can't have Protestant friends, Mary,' Tania said. 'Why?' I innocently answered, thinking this must be a grown-up thing that I don't understand yet. I comforted Tania and off we went about our play again. Though I was relieved I was sorely disappointed that I had no juicy story for my brothers after all. True to her prediction, within a week of the confession Tania and family and the dogs vanished from our lives for ever and I didn't know why but I felt very sad for her.

Tania's tale that border Catholic religion was much deeper and much different than Republic Catholic religion only struck me now, almost 20 years later.

12

I didn't sleep much the night before my first start. Apart from the fact that 6 a.m. seemed such an ungodly hour of the morning to be starting work, there was the sickening fear and anxiety to contend with. All the scenarios of what could happen while I was on the beat came into my head and scared the living daylights out of me. The uniform was ironed and ironed again, me being fresh from the Templemore precision brigade and wanting to make a good impression. However, when I arrived at the station at ten minutes to six, all I was met with were sleepy heads going off duty and even sleepier heads coming on. I was as bright as a button, babbling excitedly my introductions. God bless them, they tried to answer but the tiredness had taken a hold. It wouldn't be lifted until the most crucial of Garda duties was administered — fetching the newspaper and filling the belly as you read it.

My anxieties abated with a good feed of sausages and rashers not to mention the lovely good luck card from Tom that awaited my arrival, until this cheery big balloon of a

sergeant waltzed in. 'I'm the sergeant in charge, Fintan McTiernan *I/C*,' was his opening greeting. 'There's other sergeants over the units but I'm over your unit *and* over the whole station.' Did he want a look of awe, a round of applause from the new recruit? I looked at the others for a pointer as to what my reaction should be and all I could see were eyes thrown upwards. I chose silence as my retort.

He put me up in the public office at 9 a.m. My first client was an old dishevelled-looking character who came to the hatch. The man looked at me, opened his mouth, said something and waited for a response from me. 'Pardon, I didn't quite catch that,' I said. He repeated the statement. This man didn't look like a non-national but he seemed to be speaking some foreign tongue that I had never heard the like of before. 'I don't understand what you're saying,' I said slowly, and the four other Gardaí sitting behind me began to laugh. Pat rescued me and dealt with the dole form that needed signing. 'What language was that?' I asked as the man hobbled out through the door. More laughs. 'That's Blayney talk, Mary,' Gerry said. 'They've their own brand of English here.' Obviously I needed to be broken in.

I was sent into the town with a book of parking tickets. 'I want you to put as many of those out as you can,' said the sgt *I/C*, 'particularly outside the supermarket where there's usually mayhem there with parking.' Off I went on my own, very self-conscious, with a radio slung over my shoulder, alert to every noise and every eye that looked in my direction. People can't stop themselves looking at a uniform. Everyone does it. The eyes follow the cap and it is daunting for the head under the cap, especially on that first day. It would be a bit of gossip, of course. 'There's a new banner in town, and she's actually out on the beat on her own.' It was still a novelty at that time to have female Gardaí in some of the towns around the country.

From what I gather most people feel a little intimidated when a Garda approaches them. Their first thought is, what did I do wrong or there must be bad news. When I'm out of uniform I feel exactly the same myself. What they don't realise is that in the beginning it's equally as intimidating for a Garda to be approached by a civilian. There's a cold, nervous sweat that breaks out in anticipation of what matter may need to be dealt with. As I walked down the street somewhat apprehensive, I spied a man walking towards me. I vowed to be extra friendly. 'Good morning, sir,' I said. With that, a throaty lump of phlegm landed at my feet. 'Free State bastard!' was the reply. I walked on but it shook me, not necessarily for the bad manners that had just been displayed towards me, but for the sense of vulnerability I felt with it and for the self-admonishment at not having contested it. This was a stranger place than I had ever known before. My misfortune was that I had been well reared. This was a shock. In Templemore one of the main doctrines is not to take anything personally. Abuse is fired at the uniform, not the person, but I can tell you when you're the one in the uniform it is difficult to accept that distinction.

I continued on down the town and thankfully almost everybody else greeted me with a smile — that is, until I arrived at the supermarket where parking was chaotic and I followed the directions of my superior officer with gusto. I wrote tickets for every car illegally parked. Then I heard my radio. 'Charlie Bravo base to Mary.' 'Go ahead,' I answered. 'You've enough tickets done. Come back to the station.'

'You were busy,' Gerry said to me with a smirk and a glint in his eye. 'Congratulations, Mary,' he continued. 'You ticketed the headmaster of the local primary school, the owner of the supermarket, Fintan's wife, and I don't know

how you managed it but you've gone and done the superintendent himself.' 'How do you know,' I asked. 'Because, Mary, since you've been gone the phone hasn't stopped hopping.' I was never given another book of tickets in all my time there.

Fintan tried me out next as gaoler or BO as the older boys called it. That's Barrack Officer to you, not body odour, which I may well have had after my first two stints doing that particular job. Why? Because during my office two of the most extraordinary events in the history of Castleblayney occurred, and I was branded thereafter as a jinx. The first happened on my first night-shift. The start of the tour of duty was quiet so everyone was sitting around the public office having a laugh. Joe Quinn was the detective attached to our unit, Unit D, and though he had only a few months to go to retirement he had his nose in everything, keen as a huntsman's dog to sniff out crime. He was also a notorious joker and though I wasn't even a week in the place there wasn't a day went by that he didn't boast of the tricks he had played on people. Hadn't I been with him in the car the last early morning when we came across a tiny whining kitten? Joe thought it would be great sport to put the kitten in through the letterbox of the fastidious Garda Tom Heraty's door and have him awoken at an ungodly hour of the morning by the purring of the kitten, and he only back home from night duty. This was the same man to whose brand new car Joe had attached a 40EE bra years ago as Tom showed off his auto around the town, in all its bosom glory, without even a shadow of remorse. So when they all left the station that night in three cars, within 30 seconds Joe was shouting at the top of his voice, 'May day, May day, the whole bloody town is on fire', I thought it was a prank. I calmly countered the call with 'Yeah, right, good one Joe.' John Hobbs called in next. 'He's not joking,

Mary. There's smoke everywhere. Call the fire brigade, the key-holders, and the superintendent, Fintan and Carrick-macross station for assistance.' There was the possibility that an emergency plan to evacuate the people from their homes might have to be put into action. Thankfully, in the end only one premises was gutted and no one was injured. I took Joe more seriously after that when it had anything to do with the job.

My next stretch as gaoler was an early morning of the same week. Six o'clock start and a call came to the station that a woman was dead in a house in an estate in the town. Pat and John took the call and sure enough when they arrived at the house in question they found a woman slumped across the kitchen table. A neighbour informed them that she had heard a row taking place during the night. What a start! First it was a terrible fire and now here I was with a possible murder on my hands. Again, the list of emergency contacts was raced through and phone calls made to doctors, the coroner, control, undertaker's etc. There was the added problem that the possible perpetrator of this alleged crime was fast asleep in the upstairs bedroom. The superintendent was awoken from his slumber to oversee the matter. John and Pat remained at the scene. As the spectacle of professionals attending grew, so too did the number of spectators from neighbouring houses. What had been a whisper of a row the night before now turned into tales of blood and gore. The crowd, particularly relatives of the dead woman, wanted revenge on the man upstairs who was still in bed. The superintendent came, surveyed the scene and left, but not before he had spotted the increased tensions outside. The mob was getting more and more riotous, and by this time wanted to rip the heart out of the alleged offender. He told Pat and John not to let your man out of the bedroom and

not to tell him his partner was dead. The super wanted to let this man wake up, see two policemen outside his bedroom door, but not to tell him why. The super then left the scene.

Minutes later, back at the station, I got the call, 'Pat to Charlie Bravo Base.' 'Go ahead, Pat,' I replied. 'Check what the super wants us to do. This guy is waking up and the crowd are getting more and more angry.' I tried the super on the radio. No answer. I tried Fintan, the sergeant i/c, on the radio. No answer. I tried the superintendent on his mobile. No answer. I tried Fintan on his mobile and, surprise, surprise, no answer. Pat was getting more panicky on the radio. 'The crowd are getting up the stairs and this man wants to get out. What's the order?'

In the absence of any authority, I gave the direction. 'Bring him in.' 'Charlie Bravo Base, do I read you clearly? You said bring the suspect in.' 'Yes,' I said.

Pat and John arrived at the station with this man handcuffed after having been arrested. I thought, why did they arrest him? Could they not have just brought him in for safety reasons? But these were more seasoned cops than me so I said nothing. I took out the custody record and began writing in the man's details when Pat said, 'He'll have to be Section 4'd.' Section 4 of the Criminal Justice Act 1984 is a detention order whereby a member i/c can detain a person for questioning in relation to certain crimes. A person can be held for up to six hours initially and for a further six hours after that if deemed necessary for the proper investigation of the crime. The prisoner must be afforded his rights concerning notification of this intention to detain and that, my friends, lies in the hands of the member i/c which happened to be me. Pat had arrested this guy on suspicion of having committed a serious assault and we were just in the throes of discussing the detention when

the sergeant and his best friend, the superintendent, walked in, back from their travels in 'no radio reception' land.

'Who gave the order to arrest this man?' the superintendent spit out. 'It was getting dangerous. You couldn't be found, sir,' I replied, and with that he said nothing and walked out the door. I looked at the sergeant and said, 'Sure you're here now, Sergeant. You can Section 4 this guy.' I will never forget the look I got from my sergeant right there and then. It said everything. The big bear with fifteen years' service looked at the toddler bear of two weeks' service and said, 'This is your baby, Mary. You deal with it,' and he went off for himself. I Section 4'd my man, organised a solicitor, phone call, breakfast and a change of clothes for him, put him into a cell and then went into the ladies toilet, put my face in my hands and took 20 deep breaths and gathered myself. I have to take the initiative here, girl. Feck it! I can do this. And I did. Masses of detectives descended on the station like woodworm. I have discovered since that there's nothing like the possibility of a murder investigation to fill a detective's eyes with glee at the prospect of overtime. I refused any of them, including my esteemed sergeant, entry into the questioning room unless with just cause, and I would decide that. I carried out the rules and regulations with precision, but I was extremely thankful when two o'clock came around and I was relieved of my duty.

'Do you not want to hang around, Mary, and watch the outcome of this?' Frances, the oncoming sergeant said to me. 'No thank you, Sergeant. I've enough lessons learnt for today,' I replied, and off I skipped round the corner, into the arms of my lover Tom and spent the next two days camping and fishing in the wilds of Mayo. On my return, happily it transpired the whole suspected murder charade had been a lot of to-do about nothing. Apparently the woman had died

of natural causes accelerated by the excessive drink and prescribed drugs found in her system.

From there on I was more or less partnered in the patrol car with Gerry. His greatest advice to me was, 'Don't ever go looking for the bad stuff, Mary, because you'll have enough shit thrown at you in your career to last you a lifetime without ever seeking it.' Gerry had two reasons for sharing this wisdom with me. First, because it was true. Even if you never went outside the station, there would be sufficient complaints from the public sent in that would be meted out evenly among the Gardaí to investigate anyway. His second reason was because he usually came to work to sleep. The first hour and a half of our eight-hour shift would be spent patrolling the district or bringing post to or from Carrickmacross, the district headquarters. After that, with essential duties done, Gerry would seek out a nice secluded spot to catch forty winks. I learned two of the greatest human virtues from this great man, patience and tolerance — patience to last a boring eight-hour shift with nothing going on, and tolerance for the 2,000 decibels of Gerry Thomas's snoring.

I should have been used to snoring. My Daddy was the best snorer in the universe. Back in 1979 when interest rates soared to astronomical levels and we were forced to sell our big home and move into the mobile home in the back avenue, it wasn't the howling wind that shook the walls. No, it was my father's powerful lungs. Mind you, it generally didn't bother the seven of us that normally resided there until the weekends Helen would come home from her summer job in Butlin's. Then no one would sleep as she would spend the night taking the doors off the hinges. Helen had got used to having her own suite in the big house where Ma would light a fire in the bedroom for her every evening so the dear girl could relax on her chaise-longue in

front of it, away from the oh so stressful Leaving Certificate!
The close confines of eight snug bodies in a mobile home
didn't suit our cosseted sister. The rest of us thought it quite
an adventure being hooked up to the milking parlour for
electricity and water. The day Da drove through the gate
with a house on the back of the low-loader was like the
circus coming to town. What other family could have a six-
month holiday in their own backyard? Imagine! I hadn't
noticed that Ma had loaded on a pile of weight with the
worry or that she had spent six months previously having
heart palpitations whenever she would answer the phone or
open the door to the bank manager. What did I know of
financial difficulties at that age?

There were a lot of things I only noticed about my
mother in hindsight, like the time I was 7 and she came into
the bedroom to myself and Arthur and asked us would we
like a little brother or sister. We excitedly answered yes, and
a day later the fairies granted our wish in the guise of baby
Morgan. Did it register that Mammy had a big fat tummy
at the same time? Not at all. Then there was the time when
I was in fifth class aged 10. She came down to the kitchen
holding herself and told me to go get Daddy. 'Tell him
Mammy needs him.' I ran up to the milking parlour and he
said he'd be down in 20 minutes. When I relayed his answer
she cried and roared and screamed at me, 'Tell him I want
him now.' My heart panicked and I fell a dozen times in the
oversized wellington boots in the muck on the way back up,
with tears rolling down my face. He took one look at me,
leapt out of the pit, pushed me aside and ran to her. The
cows bellowed, abandoned, and the clusters all thumped
into the dung. Daddy carried Mammy out to the car and
sped off in the raging wind. There was a pool of blood
under the stool in the kitchen and I cleaned it up. The next
day at school Sabina Greene said a special prayer for my

Mammy and I was chuffed. What did I know of massive haemorrhages or miscarriages or several blood transfusions through the night. No one told me of my mother's near-death ordeal. It took ten years of hindsight to cop that one.

And so it was always in hindsight that I learned my greatest lessons, and in hindsight, although we had an extremely affable partnership, Gerry's influence was probably not the best for a junior recruit trying to forge a path in the Gardaí. Sometimes listening to the wise old words of experience makes it harder to jump in and make your own mistakes. I would say I was most likely placed with Gerry to instil a bit of fresh enthusiasm in him. It worked the opposite way. I only learned the bad habits from him of how to dodge.

13

One thing you couldn't dodge was border duty. Castleblayney is a border town separating the Republic of Ireland from Northern Ireland and within its district there are several border crossings. Quite frequently during my time there these checkpoints had to be manned 24 hours round the clock, presumably because of an increase in terrorist activity, or at least the threat of it. To be honest, I neither questioned nor took much of an interest in any of that. I had missed out on doing any Irish history in school by moving from Meath to Offaly in my Intermediate Certificate year. Ask me anything about the Renaissance and the Reformation and I'm your woman. It's those other little minor details of historical import such as World War I or II and Post-Famine to Modern Day Ireland where I just don't have a clue. I suppose you could say I was the ultimate in neutrality through ignorance. It suited the Garda Síochána.

I really didn't think about what person or what ammunition might be in a vehicle crossing over my

checkpoint on the border. I knew nothing about state security or terrorism. It was indicative of the instructions I had been given from my sergeant, which amounted to zilch. For that matter, the lectures in Templemore did not include terrorism either. God forbid that the young pups coming straight out of the academy might be too educated about who the major criminals were. Keep them in ignorance and let the older members take the glory for the big captures — that's the philosophy of the Gardaí. It wouldn't dawn on them that the younger members might have better sight if they knew what they were looking for and might actually be of help in the fight against crime.

So, in Castleblayney I just turned up for work and the only meaning border duty had for me was more money. I remember one four-month stretch where all my rest days were caught up with overtime and doing double shifts on my ordinary workdays. I was zonked out but it was great because I was getting massive cheques. Everyone was making money. Even if you didn't do the extra shifts, there was at least one hour's overtime guaranteed every day by the time you would either relieve the outgoing unit or be relieved by the incoming unit, not to mention the eight-hour subsistence. During these times there was always a great buzz about the station. There would be lads deployed from neighbouring districts around Cavan/Monaghan. Each change of shift saw the public office overflowing with men and their wise Garda talk and pontificating. I was well educated in cynicism about the job and how to make pay claims. All Gardaí might hate paperwork, but not when it comes to claiming sub.

The only difficult part of this type of duty was getting out of bed at five o'clock in the morning for the early shift after just finishing at 10.30 the night before and having the mandatory pint or two with the lads afterwards in the pub.

Staying awake while you were on duty in a desolate no-man's land, as most of the checkpoints were, was also hard. However, we were given the pleasure of the company of an Irish army patrol unit to assist us at the checkpoints.

Each remote checkpoint would have one Garda present and no facilities. At the same checkpoint an army troop would also be assigned. Their facilities included a tent to rest in, a portable toilet and a van that brought with it hot Irish stew at meal times. The army was well organised for these outdoor sojourns, but it became very clear very quickly that the army and the Garda Síochána were two distinct entities and facilities were not to be shared.

At first I tried to engage these big gun-wielding macho men in banter, but I soon discovered three things. One, that there are only five topics of conversation that catch their attention: the Leb (the Lebanon), drink, women, the Leb pay checks and the Leb. It left little for us to talk about.

Secondly, much as they bragged that they had seen action in the Leb, when I put it to one of them that the reason for his presence there was for my protection, his reply to me was: 'Mary, if you were shot at, you'd be suffering whiplash trying to see where I'd jumped for safety.' That instilled mighty confidence in me! And when I would look at the younger army recruits and their quivering hands wrapped around an unfamiliar gun or the lads who had come out of canteens to avail of overtime, who hadn't touched a rifle in 20 years, I felt very safe indeed!

Thirdly, it took me three weeks to discover that the Irish army soldier boys, because they had no other use for their toys, were using the night sights on their weapons to catch a glimpse of the fresh young banner with her knickers down, using a bush as a toilet. The hierarchy in the Gardaí hadn't seen fit to provide us with such a facility. During such moments I felt very proud to be a member of an

organisation with such deep-rooted archaic codes of conduct. It was with great dignity that I wore my Garda uniform on those occasions!

The uniform at the time, though it has improved since, was always the bane of a Garda's life. It was neither weatherproof nor warm nor comfortable nor safe. We had a cumbersome, plastic, sweat-inducing, fluorescent jacket that lost its fluorescence after one shower, a waterproof patrol jacket that lost its water resistance after one wetting, and gloves that made your hands colder after a spell of rain. It was misery at night-time on those checkpoints. Survival against pneumonia dictated that even though it contravened regulations, civilian clothes had to be donned underneath. The grand-daddy thermal pantaloons were just the job, as were any other warm items of clothing. Some boys took it too far. They felt sure the superintendent thought too much of his brand new car to dare drive those bockety, pot-holed roads to inspect them. He did, but a superintendent being a superintendent, would always find a way to enact a sneak attack. He decided one early morning to take a lift in our patrol car to inspect his troops. On a dark, bitter winter's morning at 5.30, Gerry, the Superintendent and I drove the windy road to Corrin-shigagh. We were met by Gerry Brazil signalling the car to stop. Gerry had almost doubled his width with jumpers and colourful jackets, not to mention the balaclava under his Garda cap. It looked like a gay, unofficial IRA check-point. The superintendent was not amused. Thence, the superintendent was not always made aware of things.

One time one of the lads left the keys in an unattended patrol car. The car went missing and an anonymous call was made to the station to inform us that it was sitting in the middle of the town of Keady, Co. Armagh, with its doors wide open. A successful rescue operation was set in

motion. No, the superintendent definitely didn't hear about that one.

Another time I was doing a mobile patrol of the border with two Irish army jeeps in tow. I was driving without a notion of where I was going. My co-pilot assured me he did as he had been there the night before. It took the sighting of a red phone box and the sound of a British helicopter overhead to indicate our incursion of the border. I had to swallow my pride and get the army guy to lead us home. With a lot of plámás to the army boys, the superintendent never heard anything about it.

I think my biggest white lie was the commission of a slight traffic accident while driving a patrol car. A colleague and I were, unusually, actually doing a bit of real police work and at the task of serving summons to some off-the-beaten-track residents in the district. It was a day that the rain was ricocheting off the road it was bucketing down so hard. As a consequence, my colleague was not too enthusiastic about walking up the pathways to the doors of the houses. The rain made the craters of pot-holes on these paths look deceivingly shallow and just when I thought I was planing yet another puddle, the next thing I knew my ears were wrenched off me with an unmerciful tearing screech. It felt as if the whole undercarriage of the car was ripped asunder. The car engine went dead. There wasn't even a click out of my baby, the little Mitsubishi Colt, when I tried to start her up again. We looked at each other and simultaneously lit up a fag. 'I didn't see that rock. Did you see that rock?' I called for assistance. Pat Rafter, the mechanical wizard, came to the rescue. 'The whole petrol tank is slashed open,' he said. 'If either of you had lit a cigarette, you'd be dead meat by now.' In a silent look towards each other my colleague and I acknowledged the sweet gift of life. The car was magically fixed by the time I

went to work the next day and there wasn't a word spoken about it again. I'm guessing the superintendent never knew a bit about that one either.

14

After nine months of being a real Garda with full powers, we reverted to being students again in Templemore for the five weeks' icing on the cake training called phase v. The gung-ho gang of phase iii, I was glad to see, had mellowed somewhat now that they had full responsibility for their own police work. Reality had bitten and in the case of two colleagues, that had taken the form of a serious beating on the streets of Dublin.

Never fall to your knees in a fight. If you do, you're a goner. Take the blasts standing and you'll survive intact. The most lethal blows are those to the head. These Gardaí had gone down. Inexperience had led the two to believe they could handle a drunken brawling mob outside a pub by themselves. They went into the midst of it without first calling for assistance. The mob turned *en masse* against them and they suffered the consequences. They survived physically but to this day, almost 13 years later, one of those two has never faced going out on the street again.

I talked with him about his ordeal, because of all the

people I trained with, he was the one that wouldn't have struck me as being easily frightened. 'That's exactly why it hit me psychologically harder, Mary,' he told me. 'I've a black belt in Karate. I'm 6 foot 7 and taller and stronger than most people. All my life I never thought anything would take me down. If I were a girl or a weaker man, I would have been more aware of my limitations and called for assistance sooner. I always thought I was indestructible. That's why it's a harder blow for me.' I couldn't help but smile at the irony of his logic. I suppose it was a backhanded compliment that we weaker beings could survive better on our wit rather than our physicality.

Reggie Barrett preferred physicality, and lots of it. In phase v we were thrust into two weeks of Riot Training (officially known as Public Order Training) under his noisy command once again. The boiler suits, big boots, balaclavas and batons were donned. With heavy helmets, shin-guards and shields, we marched into the rubble-heaped yard in sweltering heat. On a strict rota we switched from being brick-wielding gurriers launching venomous attacks, to lining up shield on shield, protecting police territory, making auspicious attempts to gain ground, only to be forced backwards by an incessant onslaught of sticks and stone grenades. Back and forth .. attack ... retreat ... attack ... retreat, with sly bricks lobbing in overhead or sneaky sidebenders coming in at the ankles. There were cuts and scrapes, broken bones and displaced shoulders, and bruises to both skin and egos during those two weeks. The Almighties were deviously taken down by the Crafties, and the Mediocres were just plain shell-shocked by the end of it. Everyone without exception was hobbling humbly. Like the circus ringleader, Reggie had finally tamed his lions.

Tails between our legs, we were then introduced to the guns. Even though the Garda Síochána is an unarmed

police force while in uniform, at some stage we would be working alongside plain clothes Gardaí who are armed. So we have to be familiar with weaponry.

Our inauguration into firepower began by sitting in a classroom decorated by a giant poster of the barrel of a large gun pointing directly at us, no matter what seat we sat in. It seemed to take up an entire wall and focused the mind well to the task in hand. We got to play with handguns for half a day, dismantling them, loading them and cleaning them. Then out we went into a target practice area cum assault course. We were given holsters, real guns and real bullets and I can tell you that the first time you don a real holster saddled with a real gun and loaded with real bullets pointed directly at your real toe, it's a pretty frightening experience. Imagine that fright, along with the knowledge that the person standing beside me tells me that he didn't quite understand what the instructor meant by 'lining up the gun' before taking a shot. It's only then I notice the obvious nervous shake in his hand. We fire one round of bullets. Then the instructor yells at us to roll over on the ground like a cowboy in a western, pull the gun from the hip mid-roll and try and shoot a moving target. Meanwhile, my partner's first round of bullets ends up ricocheting off a side wall 15 feet from their intended destination!

For those two days I believed fervently in God and all the pious saints in Heaven. I invoked the spirit protection of a bullet-proof bubble around me from every dead relative right back to the O'Connor High Kings of Ireland. And it worked. Praise God, I lived!

I lived to enjoy a simulated kidnapping and failed rescue in Tactics Town. Believe it or not, behind those great walls that surround the Garda College there is a purpose-built mini town for the honing of search and attack manoeuvres of Gardaí. Main Street, Tactics Town, Templemore, consists

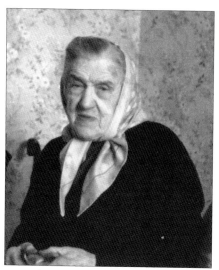

Catherine Foley, Mary's grandmother
from Annascaul, Co. Kerry

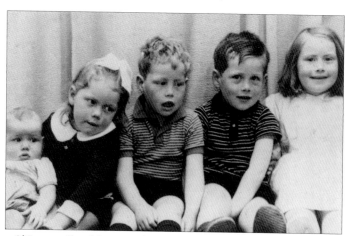

O'Connor Clan. Mary was the fourth child. The eldest was only three
and a half when Mary was born.

Mary with her mother, also Mary.

Mary's sister Helen was 28 when she died tragically in a boating accident off the coast of Long Island during Hurricane Bob, 1991.

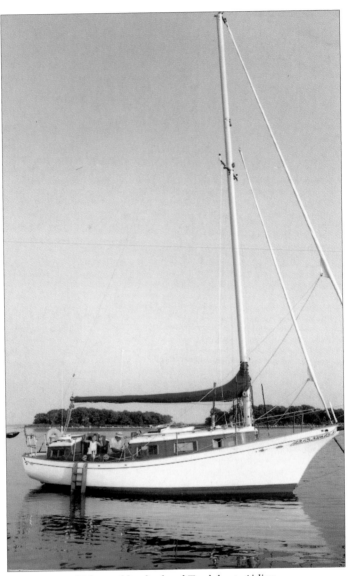
Helen and her husband Tom's boat, *Aisling*.

The Devil's Bit: Mary's refuge from the institutional Garda College, Templemore, Co. Tipperary. (Irish Image Collection)

The change from 'normal Mary' to 'Garda Mary'.

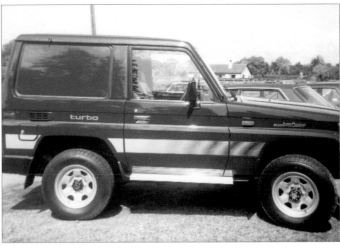

Mary was driving this Toyota Landcruiser when she was involved in a
fatal traffic accident, September 1992.

Mary and her father; he was a tower of strength to her in the aftermath
of her motor accident.

A passing out parade from Templemore.
(Photocall Ireland)

Mary with her brothers, Morgan and Arthur, on her graduation.

Mary with her sister, Edel.

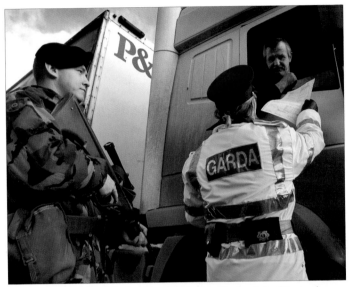

Working alongside the Army at Border checkpoints. (Reuters)

Long hours standing around were part of the job. (Photocall Ireland)

Mary, the only female garda on her unit at Castleblayney Garda Station.

All Gardaí are trained for riot situations. (Photocall Ireland)

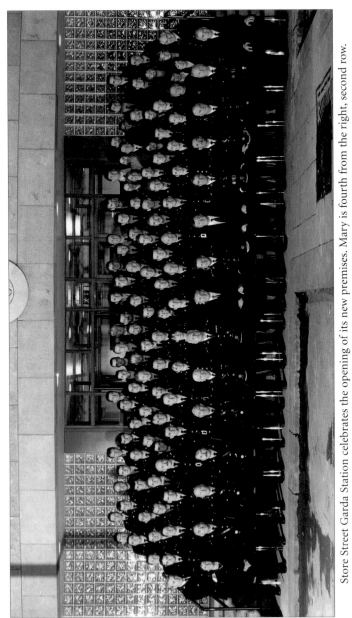

Store Street Garda Station celebrates the opening of its new premises. Mary is fourth from the right, second row.

On the beat in O'Connell Street, Dublin, with Sergeant George Dalton.

The nightmare of Dublin's Henry Street at Christmas time.
(Photocall Ireland)

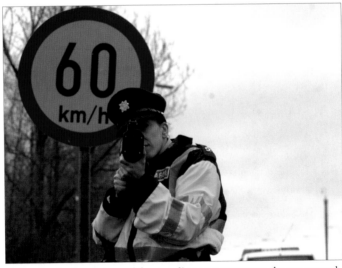
When you've been stopped for speeding, you must pass the ten-second
attitude test. (Photocall Ireland)

Part of the job was dealing daily with the horror of Dublin's drug problems. (Fran Veale)

It tears at the heart-strings to deal with the young homeless who live on the streets of Dublin. (Photocall Ireland)

Garda Headquarters, Phoenix Park. Mary worked there from 1999 to 2005, on the PULSE computer system. (Irish Image Collection)

of a bank, a post office and other business establishments that are constantly bombarded and smoke bombed in training. It's almost like a film set. It's great except that if it had been reality I would be a dead woman by now because the bad guys overpowered me! Still, we all passed.

We all nearly passed out when we were next brought into the Rec. Hall and shown a video of an exhumation of old and rotten human remains. And if that wasn't enough, we were loaded on a bus, brought to the morgue in Store Street where we witnessed a full post mortem. In my case it was that of a 72-year-old woman who had fallen over her coffee table and died. There are many scenarios that call for a post mortem. In this lady's case it was merited because she hadn't seen a doctor in over a year.

The lads thought they were so brave and could handle anything before that day. The hunter stories of shooting and cutting up rabbits were thrown at Majella, as she had expressed reservations about attending the dissection of a human body. We stood around the cadaver of this woman and watched in reverence as this inhuman act was demonstrated. Many of the boys couldn't stomach the smell, never mind the first incision, and tore out the door, hands over their mouths. I'd grown up with a slaughterhouse less than ten yards from the back door. Not only was my father a farmer, he had also been a butcher, so I was used to the smell of guts. But I can tell you there's no comparison between cutting up an animal and cutting up a human body. I had held the rope on a cow's neck many times for my Da as she was being shot. I had seen the skin being pulled from the carcass. This was different and I was curious. My sister had had a post mortem and I steeled myself to stay because I wanted to know exactly what her body was subjected to after death. I found out.

The most dreaded task to complete, and one that had to

be passed for right of passage to graduation, was most definitely for me the final run. Having recently completed my third Dublin City Marathon, that final run was a piddling affair, a mere one and a half miles around the front square in fifteen minutes or less for the women. I would walk it now. But at that time I smoked 40 fags a day and in Castleblayney I was never detailed for the beat so my earlier fitness during phase iii was long gone.

I had always been a disaster at running. My mother thought it an unnatural pursuit for a woman with boobs jumping about where they shouldn't. I was good for an anaerobic dash of 100 metres, but anything over that and Mary was gasping in a near death experience. It was imperative to get a pass in the run as my swimming results added up to a whopping zero points, thanks to Reggie. Drastic measures had to be resorted to. Before I lined up at the start I approached the assessing instructor and offered him my body. My precise proposal was: 'I may not be able to run but I've kept this body in great shape for lots of other activities!' I took to the field and after one lap a nebuliser would have come in very handy. Suffice to say that by the sixth and final stretch all the rest of the class were long gone and rested as I crawled on all fours past the finishing line. Amazingly, when the results were read out later in the gym, I appeared to have timed exactly the same as the girl who had lapped me, but I'm afraid my body was nowhere fit enough to oblige the earlier promise. My instructor hardly took me seriously. If he did he was sorely disappointed!

Exams passed, all that was left for escape from the asylum for ever was the passing out parade and graduation. It's a big affair. Families, guests, the Press, Ministers of State and the top brass of the Garda Síochána are all invited. It's a day of honour and extolling and claps on the back. Aside from our own prestigious ceremony there was also going to be

seven Scott medals for bravery bestowed on heroic Gardaí for service over and beyond the call of duty. But it wasn't the awards that made our day particularly special. Our day was made special because it was, literally, a total wash-out.

Three days earlier we had been given the option of an outdoor or indoor event. Weather forecasts were the usual prediction in Ireland of bright, sunny spells with a spattering of squally showers and the possibility of a thunder storm! Anyway, our class had put in exceptional hours refining our final parade and we had it to perfection. It was well practised with the Garda band. Naturally, pride and the desire to show off our skill meant there was a majority vote to perform outside on the square rather than have an indoor ceremony where our talents would have been lost on our visitors.

The visitors sat on unsheltered chairs that lined the perimeter of the square. The Minister for Justice and the commissioner stood on a canopied podium and in front of the podium, entirely exposed to the elements, sat our seven brave heroes awaiting decoration. Family members and loved ones sat patiently for our arrival on to the square. The Garda band struck up boldly and, I swear, at the precise moment our drill-dancing feet touched the tarmac the heavens opened up in a torrential downpour. It progressed to the mother of all rains and swirling winds. Majella, the smallest of the troop, was actually lifted from the ground before my eyes, but being the stalwart she was, kept marching on air. It was all I could do to keep from bursting into laughter.

Midway through the performance I spied the families running like the clappers for cover inside. We continued right to the bitter end and stood in front of that podium, listening to the minister address an invisible audience, then honour each medal Garda, for an interminable length of

time. The rains pelted and poured mercilessly. It was a fiasco but a memorable one and probably a fitting end to our training. It helped wash the institution of Templemore right out of my hair! And that felt good. Then, straight back to Castleblayney drove I.

15

I was still an apprentice Garda and would remain so for another 62 weeks. All the policing theory was lodged somewhere in the brain but that minor finer point of actual application had yet to be mastered. I was still not very confident in my own ability and in the beginning I was bewildered by the variety of events that occurred daily in my district.

We were only into work one morning at 6 o'clock when a passing motorist reported seeing a van miss a bend out the Ballybay Road. Pat Rafter and I headed out in that direction. We drove up and down the road several times but could see nothing. Finally a dirt mark in the ditch caught Pat's eye and we pulled over. There was no van visible, but we followed the wheel tracks through the hedge and into a field. Two yards in we encountered a deadly hill slope. Only at this point did the offending vehicle catch my eye. About 40 feet below us, a large white van lay toppled over on the driver's side and was still dangling precariously. As we clamoured down we could see a body inside.

I was sure by the ghastly pallor, contorted neck and twisted arms that were scrunched up sideways between the steering wheel and driver's door I was looking at a corpse or at the very least a broken neck. I sighed with relief when I spied the victim's chest move up and down in a slow breathing pattern. He was alive. We called an ambulance.

There was no way to get inside at him. One touch of the van would have sent it rolling further down the knoll, so the best we could do was try and reassure the driver that rescue was on the way. We got no response. He was unconscious but breathing. I knew from my First Aid training that with a neck injury it was best not to move the patient. The ambulance crew would have a neck brace and the expertise when they got here, I thought.

The van creaked, then groaned loudly, and without a word between Pat and myself we dashed to support the roof with our backs, praying we could both take the weight of its load. We were on the down side of the van. I was glad, right at that moment, that I had put on Doc Martens with good grips in the heels that morning. We held it, it seemed, for an age. All that was in my mind was to protect this man's life and get him to safety. It's amazing how that gives you phenomenal strength.

The fire brigade and ambulance crew arrived and we were relieved of our post. With all the activity around, our boy inside the van, all of a sudden, miraculously came to life. They took out the front windscreen and the man crawled out and then threw himself on to the stretcher. As he was being carted off, didn't I see him chatting away to his rescuers. He spent no more than a couple of hours in hospital, not a bother on him. It turned out he had a previous conviction for drink driving. He made damned sure on this occasion that the Gardaí weren't going to get near him for a sniff. Could you be up to people?

You certainly couldn't be up to some of the young Catholic boys of Castleblayney. We all remember the public reaction on hearing of the Jamie Bolger case in England, where the little toddler was abducted and walked to his death at the hands of two young boys. And yet right here in Ireland, not long after that happened, we had our very own Irish version of evil-doing by youngsters. It didn't end in death thankfully, but the circumstances had the hair on the back of my neck standing when it was reported to the station.

One Sunday afternoon the Presbyterian church was holding a fête and all the kids were playing out the front. A few hard chaw Catholic boys decided they would scare the Proddies and gave chase. Most of them got away back into the church except for one young boy who suffered from severe asthma. He was grabbed and brought to a makeshift shed in a bog area on the outskirts of the town. There, his abductors kept him in the dark for hours. Fun for his torturers was to get the child to kneel down in front of them and renounce his God and accept their God. The fright brought on a bad bout of asthma and the little mite nearly choked to death. The bullies absconded, thinking he would die, but luckily he got away. The perpetrators of the crime were cautioned, but imagine how at the age of 10 or 11 they could have conceived of such a crime. I didn't have to deal with that episode personally as it was passed on to the detectives because of its seriousness, but it disturbed me greatly.

I discovered disturbances were part and parcel of a Garda's portfolio. My first Christmas Day ever to work in my life was in Castleblayney. I had the nightshift on Christmas Eve followed by another one on Christmas Day. Rather than wallow in self-pity for being away from home for the festivities, I decided to cook a big turkey dinner with

all the trimmings for the other single sad sods on duty. Finbar, Ger, Tom and I enjoyed a mighty filling of delicious food. We pulled crackers, drank wine and almost forgot we weren't with our families for the day.

Fully sated, at 10 p.m. I toddled off to work with a merry grin on my face. It didn't take long for the grin to disappear. I discovered that Christmas Day is the worst day of the year for domestic disputes. I suppose, with the pubs closed, the forced niceties and the over trying, the strain on already damaged relationships becomes too much for some people. Drink, of course, aggravates the tension.

Have you ever gone to a house where you've witnessed a maniac boor of a drunkard threaten his wife and children with the turkey carving knife? The Christmas toys are strewn all over the floor, having been battered and kicked about; the wife is standing between the blade of the knife and the oldest son with her protective arms outstretched pleading for life and mercy; and over in the corner cowering on her hunkers holding on to the head of a doll you see a little 3 or 4-year old with her eyes wide open in fright, clenching on to that doll's head for dear life. All the while the bastard with the knife is roaring unspeakable obscenities. And you know that every year they dread Christmas Day because every year it means Daddy is around all day. This happens every night of the week for some people, but Christmas Day has to be the most heart wrenching for the children.

I never witnessed it myself before I became a Garda, but I have seen it many times since. And it's always the same. A woman rings the Gardaí, the Gardaí arrest the guy and take him in for the night, but by morning the woman withdraws her statement. I do know and understand the reasons why a woman might withdraw her accusations against a man that could kill her or her child, but it doesn't make it any

easier to deal with. There are times when I've seen men get back into houses and I know the full intimate details of the horrendous abuse they have meted out on their women or children, and it galls me. But more about that later.

They say you don't become a real driver until you've had your first crash. In the same way you don't become a real Garda until you have had your first official complaint made against you by a member of the public. Mine wasn't too serious, a mere charge of neglect of duty. Gerry, my partner, was a co-accused in this misdemeanour.

Four nights out of seven you could be guaranteed a vicious fist-fight outside chippers, dances and night clubs in the town. Parked in a car park, Gerry and I would watch quietly as the youngsters left the nightclub, full of drink. The alcohol could affect them in several ways, as far as I could see. There were those that happily staggered off home nice and quietly with a merry grin. There were those that toddled off, hand in hand, into the bushes for a bit of a court, or in some cases a lot more than that. Gerry, for a laugh, would intermittently turn on the headlights of the patrol car and we would see the bare bottoms rise up and fall down without shame.

Then, of course, there were those who needed a full-blooded fracas before they would be content to call it a night. In most of these cases, as soon as we would approach in the car the fight would moderate to a few shouts and roars at each other and then whittle away to nothing. Each would go off their separate ways. But sometimes we would have to jump out and pull the offenders apart. Often we would caution them and send everyone home and there would be no more about it. But on this particular occasion things were different.

What always amazed me about Castleblayney was its tough women. Perhaps it's the border mentality, but I had

never seen women manipulate their men so much. The glamour girls would literally play off the Nordies against the Southerners and cheer them on as a bone would be broken or a nose pumped blood. It was like watching a cock-fight and the women just couldn't get enough of it.

It was one of these women that formally made a complaint about the pair of us. She had initiated a fight between two bucks she fancied and they fell for it, waylaid into each other and were scrapping on the ground when we arrived on the scene. We broke up the fight and Gerry, knowing the two culprits, told them to feck off home. They did. The girl, who because she ended up not getting either man that night, complained that we hadn't made an arrest and the sergeant, who should have known better, took the complaint on board and it went to a higher authority.

It's not nice being investigated internally. It's a slur on the character sheet until you are cleared and it didn't look good on my quarterly probation report. Gerry and I therefore had to investigate this assault more thoroughly and so we interviewed lots of those who were at the scene of the incident that night. Lo and behold, it transpired that this lovely girl had started the whole affair by kicking one of the guys, head-butting the other and somehow then got the drunks to fight each other for her honour. It was with great pleasure, then, that we paid her a call, exposed her misdemeanours and gently reminded her how she could, if we pursued it, be charged with two counts of assault. The complaint against us was withdrawn and I learnt an important lesson about self-preservation in the Garda Síochána.

16

I was the only woman Garda attached to Castleblayney station, save one other. She was out on long-term sick leave so I didn't get to meet her for a year. I never thought about me being any different from the lads. It didn't seem important. I was reared in the middle of a crowd of boys and when I went to Athlone RTC and Templemore I was in the minority also. It didn't register with me that I wouldn't be on a par with my workmates. I assumed the boys were minding and guiding me because I was a junior member. It never dawned on me that their protective nurturing was because I was a girl.

I was glad I started my career in Castleblayney and on the unit I belonged to because it was like a family. The men I worked with were decent men, faithful to their wives and families, and the overall atmosphere was one of camaraderie and looking out for each other. It was the envy of many other stations and it had a good reputation. Apparently it was common for the entire station party in other districts not to talk to each other — too many bulls

in the one field. Not so in Blayney. My boys were well tamed!

My first realisation that there was an underlying, unwritten distinction between man and woman work in the Garda Síochána was when Lizzie McDonagh, a member of the Travelling community, called to the station and asked to speak to 'the lady Garda miss'. She had her cousin's wife in tow, who was black and blue and bloodied from head to foot. Her clothes were ripped, she had clumps of hair missing and there was a broken tooth sitting precariously on her lower gum. I spent hours with this woman, fetching a doctor, tending to the wounds and talking with her. Still angry at the onslaught of violence against her, the woman gave a statement in which she described how her husband had grabbed a crowbar and smashed every window of her car in on top of her while she was sitting in it. She told me how he had pulled her out and kicked the living daylights out of her, and she three months pregnant. She looked pitiful. My heart went out to her with every word I wrote and I didn't want her to ever have to leave the station. I wished I had had a safe haven for her. I didn't sleep much that night worrying about this woman and I wondered how anyone could marry a man like that. However, the next morning she came back in and withdrew her statement. She had provoked him . . . He still loved her . . . It was her fault . . . and she had crossed over the line. I didn't understand and had no legal power to pursue the matter as a result of her withdrawal. It affected me, as did every other woman and child case I had to deal with thereafter.

There's a belief in the Gardaí that because of birth gender (born female) you're automatically better at two things. The first is typing and the second is the innate ability to display empathy with victims of abuse. Because of this, at the first sign of an allegation relating to a woman or child

victim, the female Garda is called upon. It put a lot of pressure on me.

There is a general misconception among the public that we Gardaí are professionally trained in grief counselling, rape victim counselling, child abuse counselling and the like. Not a bit of it. We are thrown in like lambs to the slaughter and it's only through trial and much error and floundering and asking the wrong questions and missing silent signals and making desperate attempts to try and gain the trust of broken, vulnerable victims and investigating cases badly in the beginning, that any degree of competence is gained. There is not one Garda that doesn't have a case that haunts them, that if given it later on in their career they would have dealt with it differently — and all for the want of a little bit more training.

During my time in Castleblayney I had to deal with three sexual assault/rape cases. All the victims were minors. One girl was as young as 8 years old. It is a daunting task to have to go into a little girl's home, sit on a couch in her own sitting room and probe with unnatural questions, all the while making sure, for legal purposes, that those questions are not leading or too direct. What she says must also be scrutinised to the nth degree for authenticity, that it is not fabricated or put into the child's head by someone else. Being careful not to corrupt a child further, but yet having to get a full statement of the graphic details of the abuse, is tough. As a young recruit with little guidance it is even tougher. I had to put my first sexual assault victim through the ordeal of three statement sittings because I missed out on vital information in previous ones. I got what I needed in the end but it really caused undue suffering for the child. My training, I believe, was not adequate. It is not good enough to be doddering unprofessionally amid such traumas.

Luckily for me, my inspector put me in touch with a Garda whom I had never met before and who had dealt with many of these cases. The inspector had great faith in him. 'This is the man that will guide you, Mary. If you have any questions, he's your man,' the inspector said.

As luck would have it, one night my sergeant detailed me to work with this Garda in a completely different context. A quarry, way off out the country, had been blasting explosives during the day but some of the devices had not detonated. Our job was to secure the site. Gerry drove me out to this distant, forlorn spot and dropped me off. He said he would call back later to see if I needed anything. The Garda was already *in situ* and I hopped into his car, a full night ahead of us.

It was a desperately cold, bitter night and the rain pelted down. We engaged in introductory pleasantries and all was fine. I viewed this Garda the way I viewed any of my other colleagues and partook in general chit-chat and banter. Eventually we got talking about the sexual assault cases I was dealing with at that time and I began to ask his advice in these matters. We discussed not only these cases but other sex cases he had dealt with. Before we knew it, it was 2 a.m. and Gerry, as promised, drove in, checked on us and told us he was retiring for the night and that he would send the early morning crew to relieve me.

Inside the car we went back to our chat. This Garda divulged many intimate details about his cases and I thought this was good, he's really interested in teaching me. I soon discovered though, that he was only warming up — warming up his own libido, that is. Suddenly he put his hand at the back of my seat, leaned over on top of me and said, 'What would you say, Mary, if I said I was deeply attracted to you right at this minute?' Now this is fair enough comment between two consenting adults, until you

realise that this was a married man who was going to attend a family confirmation the next day. But there was more. There was something in the way he described such matters, that I knew the bastard was getting turned on by talking about real rape cases. My open frankness about things of a sexual nature was obviously a signal to him that I was a loose woman, just rearing to go. I laughed at him but that didn't stop him. He came in for a kiss and went straight for the buttons of my shirt. 'Stop it,' I said, but the next thing I knew he had planted a kiss on my lips and had one of my breasts in his hand. It was the filthy, foul smell of his rotten breath that jolted me to reality. 'What are you at?' I shouted. 'Stop it.' I pushed him away, looked across and saw that he had taken his penis out and was masturbating there in front of me. I was astonished and horrified

It was only then that I noticed his Uzi machine-gun sitting between us in the car and his handgun on the dash. It was also at this moment that I realised I had no radio. The sergeant had said I didn't need one. There was no let-up on his part. I never thought to get out of the car. We were parked in an open, isolated quarry in the middle of nowhere and that rain just kept bucketing down. 'Stop it,' I said again, but he just kept pleasuring himself.

Qualified Garda or not, I felt helpless. It transported me back to a similar feeling I had when I was 7 years old and I went to a football match in Croke Park with my father. There was a huge crowd and we were all sitting on benches. This old man came over, acknowledged my Da and sat beside me. Galway must have been playing, for my Da was a Galway man. There must have been an imminent goal because suddenly everyone leapt up off their seats and started roaring and shouting, excited arms flying — all except me and this old man, who took my hand in his and put my little 7-year-old hand over the middle of his

trousers and squeezed my hand over his hardening penis. I looked up at my Da with tears in my eyes. Inside my head I was screaming, make the man stop, Da. But the roaring and jumping around continued. My Da looked down for a second and looked right back up again and saw nothing. I never told on the man because my Da seemed to be his friend.

The Garda finished his dirty deed. I just stared out the window through the rain at the moon for the remainder of that endless night. 'What did your sergeant expect,' he said, 'putting a man and woman together for a night shift?' I said nothing. When I got back to the station I told Tom and Gerry who urged me to make a complaint, but I didn't. I was still a probationer, as well this Garda knew, and it would be my word against his. The fact that my inspector rated him highly was also a big deterrent.

Subsequently, I had more dealings with him. It was only afterwards that I realised the subtle ways in which he toyed with me. He would always fob me off when I approached him with any questions whenever there was a third party around; yet as soon as I'd walk out of the station and be a few hundred yards up the road, his car would crawl up beside me and he would invite me in to discuss the cases. I discovered his car was his vehicle of control over me, his haven of power, and he was somehow energised at my awkwardness under his command. I stopped getting into his car but he just got braver. I watched him relish moments when he would close over a door and lock the two of us in a room together or when in a crowded room he would deliberately seek out the chair I'd be sitting on and put his jacket on the back of it, so that he could brush against me at the same time. How do you report something like that? I have my suspicions about this man, Inspector. You shouldn't be giving him these cases. He has the tendencies

of an abuser himself. How would that have gone down? I would be told I was paranoid and branded a 'dangerous woman' throughout the force.

Around this time there was a new European initiative, EU funded, called NOW (New Opportunities for Women). There was a huge political lobby to show that the Garda Síochána was not antiquated in its treatment of women in the job and so no expense was spared in organising a national conference for the Garda girls, *just to show how much we care*! Templemore was the venue and it was a three-day course. We were given lectures by leading ladies in equality and reform, one of whom said we should wear a badge to work which read 'I taught Lorena Bobbitt'. That would have sorted out my friend all right! But joking aside, this conference was the first time I got to talk to other women in the job and the first time I realised I did miss female company and that I had been trying to be too much of a lad in Blayney to fit in. When we were put in workshops, the revelations that emerged about the treatment of us women were shocking. One girl related to us that her superintendent had called her into his office and said, 'You're a good-looking girl. You know what to do to get promoted.' Another girl broke down and tearfully told how her sergeant in Command and Control constantly bullied her, roared abuse at her and called her a fool all the time. Derogatory remarks, inappropriate sexual innuendoes and misogynist behaviour appeared to be rife in the job. It became clear that it was mostly directed towards junior female members, the most vulnerable, the ones who don't have the power to retaliate. The older members were frustrated that they had to become 'hardened bitches' to deal with the levels of discrimination against them. It was a nasty eye-opener, but we were fooled on two counts. We were fooled into giving information at

these 'confidential' workshops, and fooled again into thinking that the NOW initiative might help our plight. Our complaints were noted and then unceremoniously thrown in the bin. Or, as happened in my case, thrown back at me as a joke. Two years after this conference, I was sitting in a pub in Dublin with a crowd of Gardaí when one of them said, 'You're that one that pulled a Garda off in a patrol car, aren't you? Any chance of me being detailed for a night shift with you? Ha Ha.' Yes, life is just one hilarious joke after another as a woman in this job!

17

'It has been brought to my attention that you don't go to Mass, Mary,' one concerned Garda, on the advice of his pious wife, said to me one morning at one of my monthly reviews. 'That's right,' I replied, 'I don't believe in it.' 'Mary, it's not whether you believe in it or not, it's about public image. You need to be seen at Mass, it looks good.' 'Is that right?' I said. 'What if I was a Buddhist?' 'You remember, Mary, your behaviour is being watched by the community all the time, the pub hours you keep, who stays over in your flat, what you do in your spare time. It's important to present yourself right.' 'Thank you very much for your concern. I'll bear that in mind,' I said. Inside I was thinking, you nosy buffoon. Who appointed you my moral counsellor?

Obviously this was a back-handed attack at my ongoing liaison with Tom, not to mention my twice weekly drinking sessions around the town with the boys on Unit C. Well, I wasn't going to give up the only bit of fun I was having with the boys. Tom, however, was a different story. We had

started our flight of fancy when both of us were in the throes of personal trauma, and it was very intense, too intense to sustain. Those ardent daily letters full of passionate thought and feeling — where do you go from there? Tom actually did leave his wife, but he relied too much on the fact that he could walk straight into my life full time after that. I don't think it's possible to do that. The whole relationship started off too clandestine. Whereas previously we were always so careful not to be seen touching each other in public, now Tom wanted to be holding my hand walking down the street. It was a strange new situation and it didn't sit comfortably with me. It broke my heart and I broke his heart in severing the relationship. It broke his heart so much that two months later he rang me to say he had fallen for another and was getting a transfer down the country to live with her! Some people just thrive on complications.

With that complication out of my life and now having no need for an apartment on my own any longer for secret rendezvous, I moved into a house with the boys on Unit C and I started to get into this policing business good and proper. I began to be a real Garda, but it was hard. Every single day was different, every incident a learning curve with a twisted adventure. The biggest lessons learned were that the behaviour of human beings never ceases to amaze and that expectations from the Garda can be enormous.

One night I was called to the scene of an accident where a man had been knocked down. He was lying in the middle of the road with his head split open and blood streaming like a river out of his skull. I immediately applied pressure to the source of the blood. What more could I do except wait for an ambulance? Well, waiting for that ambulance to arrive from Monaghan for a full 40 minutes was torture. Forty minutes I can tell you is an eternity when you're

kneeling down on the tarmac holding a man's head together and a crowd gathered around, each with their own opinion. 'Stop the blood.' 'Can you not do anything else?' 'It'll be your fault if he dies.' There must have been 20 people standing around roaring comments at me about my incompetence at not performing a miracle by curing this man on the spot, rather a lot to ask of someone who had only basic first aid training! It turned out he was fine. I learned that fresh, flowing blood always looks worse at the scene of an accident. I also learned to expect admonishment rather than help from public spectators at such scenes in future. I generally wasn't disappointed.

On another occasion, Pat Rafter and I were called to an accident involving an articulated lorry that had jack-knifed. The trailer ended up leaning sideways and almost blocking the road. We were there mostly to redirect cars safely until the lorry was taken off the road. Thankfully, no one was injured, nor was any other vehicle involved. I took position at one side of the lorry and Pat took the other. For almost four hours I happily waved all oncoming traffic through the detour round the lorry. It was a hot evening and I thought to myself that it must be the sunshine that has everyone so good humoured, for without exception all the drivers that passed me gave a big smile and a wave. Even the kids in the back seats of cars were waving at the Garda. That evening I was quite proud to be wearing a uniform and to be of service to the community. Just then a driver called me over and asked me where the cameras were. I looked at him, confused. 'What do you mean,' I asked. 'Are Lyons Tea not doing a commercial?' he asked. He had me flummoxed until he turned the side mirror of his car to let me have a look at myself. No wonder everyone had been laughing. The cute elder Garda had positioned me downwind of the lorry which was full of coal, and the gentle breeze had

covered me in black slack. For all the world I looked like one of the Black and White Minstrels, a white-toothed, white-eyed, black-faced performer. Wasn't I a source of great entertainment for all the passers-by?

Another night, a man called into the station and reported that he knew he had hit something in the middle of the road but wasn't sure what. He thought it might have been a black bag but suspected, with the thud, that it may have been a person. He had searched the road but couldn't find anything. It was a pitch-dark night with not one glimmer from the sky and a search party was mustered. Out the Keady road at the first bend on the far side of the town, a team of four Gardaí were deployed to search with the assistance of bad torches. Three hours of rummaging through ditches and mucky fields on either side of the road produced nothing. Just as the search was about to be called off, Gerry let out a shout. He had found a head, unattached, in the muddy waters of a four-foot ditch at the side of the road. He was an old man, who had been drunk, obviously staggering along the road in dark-coloured clothes on a black night at a bad corner. It was an unfortunate tragic accident where the driver had no chance of avoiding him and the victim had no chance of survival.

I never passed Joe Feighery on the Belmont road from Cloghan after that without giving him a lift. Poor Joe was the resident, unrelenting bachelor alcoholic who lived in a house that had the ashes from the fire piled almost six feet up the wall inside the front door and not a bit of glass in the windows. He survived winter after winter, thin as a rake, with the same unwashed clothes for as long as I knew him. His only food was good old whiskey. Once I would see the bike abandoned on the road, I would know Joe was in a ditch not far from it. And after dragging him into the car

the conversation was always the same. 'Thanks very much for the Christmas dinner and tell your mother she's a great cook.' I don't know how it started but it had become a yearly tradition in our house to bring a Christmas dinner up to Joe. Before anyone else in the O'Connor clan got a morsel of food, there were three plates brimming with turkey, stuffing, ham, Brussels sprouts, pudding, mince pies and trifle ferried up to Joe by my father. It was a good tradition. I suppose it was to teach us to think of those less fortunate and without families on such extravagant occasions. What is amazing is that he died of natural causes in the end despite multitudinous nights stretched out paralytic in the middle of the road. Wasn't he a lucky man he was saved from decapitation and some innocent driver thinking he was a black sack?

So this was Garda work, every day different, at each call-out not knowing in what capacity you would have to act, medic, mediator, body-finder, form-stamper. That was just for starters. Slowly but surely I was beginning to get a handle on it. One thing I wasn't getting a handle on, though, was arresting people. There's not much need to be arresting people in a small town like Blayney and, as well as that, Gerry and I were just too damned nice, who much preferred harmony to discord. We would rather take the keys off a drunken man before he got into his car than let him start it up and then arrest him. It worked well for us and for the late-night drinkers who appreciated the chance they had been given. But it didn't work well for my sergeant who decided to take a particular personal interest in my work rate i.e. arrest returns. And so it came to pass that I was taken off Gerry's unit and put out to graze, or was that guzzle, with a more progressive unit whose explicit order from this new sergeant was — get Mary her first collar.

There's a massive difference between going out at night in a squad car to cruise around a town on patrol and cruising around with the specific intention of making an arrest. It automatically changed my role from observer or mediator to that of aggressor. It was not a natural state for me. For three nights I was sent out with three different drivers, all hell bent on finding me a capture. They turned out to be the three quietest nights in the history of Castleblayney. This did not deter the diligent Tom Griffin from ensuring his underling was going to gain her wings. It turned out to be a comical affair in the end and my first arrest, I have to admit, was a pathetic one. Twenty times we circled the town in search of that elusive character who would enhance my progress reports, but to no avail. On the twenty-first route, a poor misfortunate, drunken man staggered out on to the road in front of us. 'Here's your chance,' Tom said to me. I got out of the car and approached the man. Though incoherent, he was so pleasant my heart went out to him and I directed him back on to the footpath and told him to go home. Tom was not impressed. Ten minutes later the gods presented the same poor sod in front of us lying stretched out in the middle of the road. Again I got him to his feet and put him on the track home. The third time I pleaded with Tom. 'Could we not take him home ourselves?' Eventually on the fourth encounter I made the arrest for being drunk and a danger to himself and other road traffic users. He slept it off in the station and I had to endure a slagging from my old unit about harassing poor drunken men.

I thought that would take the wind out of the sergeant's sail and he would get off my back for a while. Not at all. Nothing would do him but that I would have a drunken driving arrest under my belt. He orchestrated a plan. The two cars would go out to this little country pub five miles

out the road. Car 1 would raid the pub for after-hours drinkers and car 2, my car, would have a checkpoint set up 200 yards up the road just round a bend. 'I don't want to see you back at this station without a Section 49, Mary', was the direction from my sergeant. I really didn't want to make an arrest under those circumstances, but what could I do? I let several drivers go, but eventually my colleague stopped a car, beckoned me over and said, 'You have one here, Mary.' I made the arrest, my sergeant was happy, it looked good on my mark-up card, but I felt awful. It didn't sit with my sense of fair play and I swore I would never arrest under duress again.

It was around this time I was beginning to get itchy feet. The sergeant was right in one sense. For a young Garda learning, Castleblayney probably wasn't the best place to be. Added to that there were the by now daily nauseating encounters with the other pervert Garda whom I despised, but there was to be one final incident that eventually spurred me to put in for a transfer out of the Cavan/Monaghan Division.

I was sharing a house with the lads from Unit C. It was literally seven doors up from the Garda station which was handy for struggling down to work with a hangover, but even handier still for the sergeant who could call upon you whenever he would have a gripe about something. It was a cold, dark, small house, darkened even more by the six-foot, overgrown, weed-infested back garden jungle. The floors squeaked, the kitchen was damp and the walls were a gloomy, depressive dun colour throughout.

Initially there was Ger, Finbar, Pat and myself living in this squalor, though it was a happy squalor. We all got on the finest and had a great laugh together. We also always had the best of sirloin steak to cook, thanks to Pat who, being the apple of a doting Leitrim woman's eye, a woman

who would go at a loss herself to feed her adorable Leitrim County footballer son.

We had plenty of giggles and good feeding for a year or so and life was good until my roommates, one after the other, started to get transfers. First of all Finbar was transferred to Hackballscross and he went back to live in Dundalk. Then Pat got a Longford station not far from home and his Mammy was delighted she could indulge her baby on a daily basis again. Finally my greatest pal of all, Ger, was transferred back to his home county of Clare. No other lodger after that ever came close to the kinship we first four tenants had.

Castleblayney being a border town, there were several known IRA activists around who were being observed by the Gardaí. There was a book in the station with details of sightings of where, when, with whom, and in what vehicle they were travelling. To be honest I never paid much heed to this particular practice, but I was aware that we, as Gardaí, were being equally scrutinised and better collated by these activists. These boys, and one in particular, patrolled the town every single day and sometimes twice or three times a day. No doubt he had more information in his little black book about the people of Castleblayney and the whereabouts and movements of the Gardaí than we had about them from our sparse, crumpled bits of paper pulled out of back pockets. In my happy, innocent, empty-vesseled world, this all passed over my head.

There was only one night ever I stayed in that house in Blayney on my own. With shiftwork and being on different units there was always someone either still in bed or hanging around the house. I felt very secure. However, one morning at 5.30 whilst still half asleep and due at work, I opened the front door. Instantly, I took a six-foot jump back in terror and a thumping heart as a huge puff of

smoke and a simultaneous thunderous bang exploded in my face. Shaking, I gathered myself and took a look at the door, only to find a makeshift device of string and putty hanging from the latch. It didn't look all that dangerous and I wasn't injured, just a bit shocked. My first thought was that Joe Quinn, the joker detective, had mastered the plan for a laugh, or if not him the lads on the night unit who had feck all else to do but plot such a prank. I picked up all the pieces of the device and presented them to the night unit as if to say, you got me, you bastards, but I didn't like it. I knew by the completely blank faces that they had no hand in the matter. I challenged Joe and the rest of my own unit. Again, blank faces. As the day went on, there was a slow realisation that this trickery was some kind of warning: 'We know when you're on your own. We're watching you always.' The device was more elaborate than a little child's Hallowe'en banger and that's what scared me the most. This had been deliberate and had been done for me specifically. Maybe I should have done as the sergeant had advised and gone to Mass regularly after all.

That put the nail in the coffin for the town of Castleblayney and me. I submitted a transfer application for Dublin. I decided it might be a good idea to finish my degree which would give me more options for a career other than the Garda Síochána. I applied for and was accepted back into UCD 3rd year social science. Now all I had to get was a convenient station close to UCD, Belfield, Dublin, and so on my transfer application I put my first choice down as DMA East, the haunt of my student Garda days around Blackrock, Dun Laoghaire, Bray and Dalkey. My transfer was recommended and I was thrilled when I got the phone call from Personnel to tell me I was successful. When I asked what station I was going to, the voice at the other end of the phone went a bit quieter. 'To

be honest, you didn't get just exactly what you asked for, Mary, but it is Dublin.' 'Just tell me,' I said. 'In five days' time you have got to report to the sergeant in charge of Store Street Garda station. Congratulations!'

18

I grew up for the most part outside Trim, Co. Meath, on a 200 acre farm. We were as strong as horses, probably something to do with the fact that we each guzzled bucketloads of full-fat, unpasteurised milk like suck calves. We would each have a pint of milk with five Weetabix for breakfast. As soon as we would walk in the door from school we would have another pint from the fridge to quench the thirst, and another pint each with the three-course dinner of home-made soup, spuds, meat and vegetables, followed by custard, of course made with lots of milk. None of us ever had extra weight on us. We would work it off on the farm or fight it off with each other. One fight I would always lose on the dark evenings would be who would be the one to go up to the milking parlour to replenish the milk jug in the fridge. It was a dreaded ordeal, an obstacle course for which gargantuan bravery was required to survive. Somehow I always drew the short straw.

The first hurdle to overcome was getting past Angelo in

the back kitchen. Angelo was a huge playful fool of a St Bernard dog whom Da had rescued from the kennels in Dublin when he was passing by one day. He was only a few months old but he was already gigantic and not particularly amenable to orders. Having been reared a Dub dog, Breemount Hill and its green pastures was like transporting Angelo to puppy heaven and he lost the run of himself completely. All of us had black and blue bruises all up our arms where he would be tugging at us to get out to the fields. He was locked into the back kitchen at night-time and I would only have to tip-toe one step into the room when this giant would leap in the air and land me flat on my back. It used to take several falls before I managed eventually to get the wellington boots on and be out the door.

But could I leave my guard down and catch my breath? No way! As soon as I achieved that success against the dog, I would have to spark up my sharp wits about me to contest the white cock. This vicious, malicious masochist resided in the open yard around the house and at the sight of a human, he would make an almighty charge, jump in the air and attack remorselessly. I was petrified of this savage. As with Angelo, several attempts at escape were required before successfully skirting the tyrant's path. And all that was just half the journey. Trust me, friend, it was twice as difficult on the way back down again with a full jug of milk!

So do you think I was frightened to get Store Street, the busiest police station in Europe, with the highest crime statistics in the country, the home of Sean McDermott and Sheriff Street and with a huge incidence of drug-related crime, not to mention one and a half million people per day walking down the main streets of our capital? Absolutely. I was scared shitless!

Store Street was like being thrust into a completely

different universe from that of the small country town of Castleblayney. This den was a hive of buzzing activity from the very second you stepped inside its door, tripping over prisoners to get to the parade room for the beginning of the shift pep talk from the sergeant. In Castleblayney the station personnel numbered 20 Gardaí and 4 sergeants. Here in Store Street there were close to 300 Gardaí and at least 3 sergeants per unit. At any one time there could be up to 30 Gardaí being paraded for their start of duty. And just like the beginning of every *NYPD Blues* episode, the sergeant would sit at the top of the room and spit out any complaints or major events that had occurred in the last 24 hours, as well as anything that now needed close attention.

'Beware of abandoned fridges!' the inspector shouted from the top of the room. I wondered if I had heard right, when again the thunderous warning was repeated. In a serious tone he proceeded to tell us: 'Should you happen upon an abandoned fridge on O'Connell Street, be very careful. Do not, I repeat, do not use your radio within a hundred yards of this potentially explosive device. Cordon off the area, call me on a phone and we'll get the bomb disposal unit out to deal with the matter by controlled explosion.' No one laughed and I pondered on whether I had accidentally drifted into the wrong asylum!

The sergeant followed: 'Charlie 75 Capel Street beat and pay particular attention to No. 45. Got that?' 'Yes, Sergeant,' I replied. This was it. No one was going to hold my hand here. I grabbed a radio and as I set off, I not only hadn't a clue where I should be going but I was also terrified that I was going to meet an abandoned fridge *en route*!

Luckily, Lionel Mullally, a community Garda for Dominick Street took the new kid on the block under his wing. He sidled up the street with me, giving me the low-down on city life, which sergeants to keep an eye out for

and general chit-chat and gossip regarding other members. I was glad of his company. He walked me round the entire C District on that first night. It went from the Quays to the south side of Parnell Street one way, and from Alexander Road in the North Wall to the east side of Capel Street the other way. The legs were hanging off me by the time I got to the spot I was supposed to be patrolling in the first place, and I discovered that No. 45 was not only *not* on our side of the street (it was part of the Bridewell District), but that this establishment was an adult sex shop! Wasn't my sergeant the crackling joker, now wasn't he? The next morning when he again paraded me, he enquired how I had got on. 'The premises was closed when I got there,' I said. 'I'm afraid I didn't get a chance to avail of its offers.' He simply grinned and said, 'It's a bad day when you don't learn something new, Mary.' Both my sergeant and my inspector were doing a great job of bolstering my confidence in the higher ranks!

Lionel took it upon himself to be my mentor in that initial phase. The second day out was a 10 a.m. start and within 20 minutes had him showing me how to arrest a shoplifter. Within 30 minutes I was arresting one myself. In fact, during the first three hours of that tour of duty I had two prisoners arrested and was in court by 2 p.m. I didn't really have time to be nervous beforehand, but as soon as I walked in through those court doors, I realised I hadn't a notion what was expected of me. I may have had two arrests in almost two years in Castleblayney, but none of them had actually reached a court yet. Most prisoners were summonsed in the country so cases can take several months before they make it to the courtroom.

In the courtroom I watched the other Gardaí intently but the cases were run through so quickly it all passed over my head. Eventually my first case was called. 'The DPP at the

suit of Garda Mary T. O'Connor versus John Doyle.' I
stepped up on to the rostrum, held the Bible in my hand
and shook like a leaf in a storm. That first 'I swear by
Almighty God that the evidence I shall give to the court in
this case shall be the truth, the whole truth and nothing but
the truth,' and remember, *don't* say 'so help me God', has to
be the most nerve-racking experience for a Garda. After I
ran that off my sticky tongue, I froze. I looked at the judge.
He looked at me, waiting for my evidence. I looked back at
him and my mind was still blank. 'Have I a fool in my
dock?' he roared. 'What's wrong with you, Garda? A few
words too complex for your intellect?' I held back the
fright, looked at Lionel, who mouthed the words to me: 'At
11 a.m. I arrested John Doyle, conveyed him to Store Street
Garda station where he was later charged in my presence by
Sgt Phillips. In reply to the charge after caution he had
nothing to say.' I somehow managed to speak the words and
I asked for two weeks' remand on bail for plea, which was
accepted. I stepped down and thought to myself, by the
time the next court date comes round I'll be damn well
prepared for the judge.

Prepared? Was I hell! Every single day saw shoplifters
thrown at me and every single night drunks acting
disorderly that needed arresting. The workload was
immense and learning was done through bad experience. I
found the judges terrifying. Many of them had little
tolerance for amateur displays from young Gardaí.
Sometimes it felt like we were more on trial than the
accused with the treatment of members by our esteemed
judiciary. It was not unknown for Gardaí to be placed in
contempt for letting their mobile phones ring during
proceedings or to be seen chewing gum. What a formidable
crime — masticating in a public place!

A friend who had trained with me and who was stationed

down the country told of her awful ordeal in court when she had arrested a guy for urinating in a public place. The defence solicitor had actually suggested she had a fetish for seeking out men that were exposing their 'tackle'. He badgered her about her 'obsession' with this particular type of offence and made a laugh of her in the box.

When she sought a stop to this line of questioning, the judge would have none of it. 'Answer the man,' he demanded. 'Do you have a fixation?' She was not only highly embarrassed but thoroughly disgusted and sought, through her superintendent, an apology from the judge. He gave a sincere retraction at a later date, but of course the damage to her reputation had been done. Yes, it is pretty funny, but not when you're the one at the receiving end and being made a laughing stock in front of a courtroom of prisoners who, no doubt, will use it as ammunition in future encounters to undermine your authority.

Judges can say what they like, and they generally do. Some are hilarious. I will never forget one judge's sentence for a prisoner held before him in court. He was up on a charge of shoplifting. The case proven, the Garda was asked if the prisoner had any previous convictions. The Garda took from his file a ream of paper with innumerable convictions. There must have been over a hundred sentences already given. 'This is outrageous,' bellowed the judge. 'There's no point in me giving this man any further time in prison. It's obviously not working. I hereby sentence this man to picture recognition throughout every shop in Dublin. We must make posters of this man's face and put them up everywhere just like the Ayatollah Khomeini. Perhaps that will be a deterrent to him!'

Another judge who was also notorious for her sentences made grown men cry in her wake. There was no doubt who ruled her courtroom. She was god. One of her beauties had

to be giving a man, who had been brought before her on a cruelty to an animal charge, a 10,000 word essay to write as to why he shouldn't hold chickens in a locked-up van on a hot day.

A Garda always has at least one particularly memorable court case. Some are for very grand reasons, be they murders, rapes or serious crime cases that were well investigated and merited a conviction. Most of us remember days out in court for their embarrassments, indignities and guffaws. I'm not sure which award category mine would fall under.

Life was hectic in Store Street. Being on the flexi-unit meant that for the most part my duties were city-centre beats, four hours on North Earl Street followed by four hours on a post standing outside the GPO, or four hours on Upper O'Connell Street East followed by four on Lower O'Connell Street West — just for variation! By far the busiest beat was Henry Street.

Henry Street was a buzz of piles of passing people, window shoppers, crying, lost little people, lost big people, tourists, shoplifters, pick-pockets, beggars, buskers and the most daunting of all, street traders. There's a long tradition of street trading in Dublin's city centre. Generations of families as far back as can be remembered have plied their wares in Dublin's streets. For the most part they're a decent bunch. There are those that have licences to trade, and there are those that don't. With those that don't, there's a cat and mouse game that's played with the Gardaí. Here's what happens.

The superintendent gets a call from a prominent business person complaining that the traders outside their door are affecting their business. The superintendent roars at the sergeant, who in turn roars over the radio at the Gardaí to move on the undesirables. The Gardaí, in response, stand at

the top of Henry Street/O'Connell Street, make their presence obvious so that the whisper precedes them all the way down the street. Generally the trader is gone before the Gardaí get there. It's a good game. It usually works.

That is, unless you're dealing with one particular lady (let's call her Lucy Farragher) and her two sidekicks, who get a thrill out of scaring the living daylights out of the fresh meat, new Garda. Garda Josephine Delaney and I had the privilege of such an encounter when I was hardly a week in the place. As we haplessly patrolled down Henry Street I, wanting to establish my authority in the territory, innocently asked Ms Farragher if she had a licence to trade. She effed and blinded me in a tirade of foul-mouthed abuse. When I asked her again for the licence, out of the blue she slapped me across the face. Two of her partners jumped in and grabbed my partner. In a flash both Josephine and I were being held up against the window of Eason's shop outside the ILAC Shopping Centre, with the three of them kicking and hitting us. We were completely powerless to do anything. All the while, Lucy was roaring at the top of her voice, 'Police brutality! Police brutality!' Tell me, where's the brutality when you're dangling by your throat? I swear that a crowd of at least a hundred people gathered round. Even though Ms Lucy Farragher, who was the female equivalent of the Incredible Hulk with her size and her power, and her two fogies were laying into us, not one person came to our assistance. It seemed an eternity before one man ran from Eason's and pulled Lucy off me. Between us we gained control of her. Her two collaborators took a hike as soon as they saw Lucy being overpowered. We eventually got her into a van and transported her back to the station, with no let-up of verbal abuse from the bold Lucy. As soon as we got inside the door of the station, she turned into a lamb — an instant transformation to a meek,

hard-done-by, tearful innocent, claiming she felt a bit nauseous. 'Are you all right?' asked the sergeant who took pity on the whimpering witch. His concern extended to not putting her into a cell and he let her sit in his own personal chair until the paperwork was processed. He then made her a nice cup of tea, ordered a meal for her and later charged her, bailed her to appear in court the next morning and then walked her to the door as she left. 'Myself and Josephine are fine too. Thanks for your concern, Sergeant,' I sniped at him as he detailed our return straight back to the scene of our thrashing.

Next morning saw me sitting in the court awaiting my first assault case. As luck would have it, my wonderful adviser Lionel also had a case before the judge and I went through my ordeal with him. 'What kind of language are you allowed to use in court?' I asked him.

'Anything at all. Why?' he said.

'Well, it's just that Lucy's reply to the charge is not very nice. I can't surely say that to the judge,' I asked, as I showed him what her response had been.

'Mary,' he said, 'you must tell the truth. That's what you're swearing to do, isn't it?'

My case was called. I steeled myself when after the oath I began, 'Judge, I arrested the accused yesterday on Henry Street. In reply to charge after caution the accused said "I didn't hit her. Them two beat me up. She's only a fucking, poxy, carrot-head cunt."' The court erupted in laughter and I could see tears coming down Lionel's face.

You bollox! I thought, but then the judge looked at me and said, 'I'm sorry Garda, could you repeat that again.'

'Judge, I arrested the acc . . .'

'No, not that part, Garda, just the end part. I didn't get a chance to write down exactly what she said to you,' the judge interrupted.

I repeated the quotation: 'I didn't hit her. Them two beat me up. She's only a fucking, poxy, carrot-head cunt.'

Again the court exploded in convulsions and the judge, playing up to the audience, again asked, 'Sorry, Garda, but I'm not that quick a writer and I really want to get this down. Can you repeat those last four words, maybe a bit louder this time. Maybe you'd speak right into the mike, please.'

'Fucking . . . poxy . . . carrot-head . . . cunt,' I shouted, very slowly so that I could be released from this humiliation, or more to the point that I could hide the beetroot face that highlighted why I might have been branded a carrot-head in the first place.

The case went through several court dates before it reached its three-month conviction for Lucy. Each time, I had to suffer the indignity of a snigger or sneer from whichever judge might be presiding. 'The accused doesn't much like redheads, sure she doesn't, Garda?' I heard a thousand times. Lucy was out on bail the whole time the case was being dealt with and the day she did get her conviction I lodged her in Mountjoy Women's Prison. By the time I had walked back to Henry Street, an hour later, there was Lucy, in the flesh, trading again. The prison, just like my sergeant, had given her a cup of tea and instantly let her go on temporary release as there was 'no room at the inn' for her. There were many lessons learnt that day, the biggest of which was not to rely on Lionel Mullally's advice in future. The one good thing that came out of it, though, was that Lucy was less abusive to me after that and played the traders' game from there on in. The new kid had earned respect.

19

Respect, though, doesn't last very long. And if you think you've got it, you're only indulging in a moment of self-gratification. As I walked down Sean McDermott Street in uniform, I found that the young 3-year old might run over and say hello to me with a big smile on her face, but running after her would be the 4-year-old brother or sister who would grab her and drag her away shouting, 'What are you talking to that effing gee-bag for?' At 4 years old — and the parents would encourage it. These little people were more streetwise and brazen than any I had ever encountered. Although my first instinct might have been, you little toe-rag, I'd love to clatter you one, I then thought, Jesus, what a waste! If that same confidence could be channelled into good, we would have some powerful little people here.

I don't believe the general public of this country knows that there's a whole other breed of children out there that are born into tough households, where kids crawl over dirty syringes on the sitting room floor as babies, have to

fend for themselves at the age of 3, steal cars when 5 or 6 and learn to give their parents a fix by the time they're 7. These are not stupid, mindless people. They are highly intelligent neglected kids who just have no other direction or influence but the wrong one. They don't even know it's the wrong one. These are youngsters who have the wherewithal to finance themselves by robbing at an age when suburban parents are still spoon-feeding their precious babies. They are miles ahead of us.

There's the story of the man who locked his car keys into his brand new, state-of-the-art, alarm-protected BMW on Talbot Street and a young child of 7 approaches him and says, 'Hey, mister, I'll get your keys for you if you give me €40.' Mister ponders and thinks to himself, it would cost me a lot more to get a locksmith out and replies, 'OK son, but don't damage the car.' He gives the youngster the €40. Young child runs down the street, but before mister has time to panic, thinking he has just been conned, the 7-year old comes back up the street with a sledge-hammer, swings it up in the air and gives the front wheel of the beautiful BMW an unmerciful wallop. The locks on the doors release instantly because the electronics read the thud as a major road impact. No damage. Problem solved. And the young wizard is €40 richer. You can't but admire that.

And you can't but be amused when, as happened to me one day when acting as gaoler in the station, two Gardaí arrived with a joy rider who was barely out of nappies. The prisoner's counter in Store Street is about three and a half feet high. I had to lean over the counter to get a look at the culprit before me. 'What is your name?' I asked. He told me. 'And what age are you then, young sir?' I enquired. 'Eight,' he said. 'Sure how could you be driving? You wouldn't be big enough to see over the dash,' I asked him. The child became indignant, pushed out the chest and dismissed me.

'Fuck off. I'm driving since I was 6.' How could you not laugh? Can there be a turnaround? Or is it too late at age 8 to step in and try to reform these children? Perhaps not.

I had one other beating while I was in Store Street station. Again it happened on Henry Street and it was during the hectic trading season of December. Because of the extra trade at Christmas there are licences given to traders to set up stalls the whole way down each side of the street. It's pedestrian hell. It was just my luck to be detailed to inspect the licences. I stopped at one stall and as I was engaging in a bit of banter with the stall-holder, out of nowhere this lump of a lass started cursing at me for daring to ask the trader for her licence. I said, 'This has nothing to do with you.' She slapped me across the face, knocked the cap from my head and proceeded to kick me and swing me around with my radio strap so that I couldn't call for assistance. I'm afraid none of the four judo holds I learned in Templemore, under safe conditions, quite sufficed for this surprise attack. I was battered around until Paddy Boylan, another Garda, ran to my assistance. He had heard of my predicament, not on his radio or from any concerned citizen but from the traders' excited shouts to each other. 'Redser, the banner, is getting a beating.'

The girl was 14 years old, about 5 foot 10 and easily 12 stone. (Let's call her Lizzie Connor.) She swallowed up my smaller frame like a cat would stun and then play with a helpless mouse. She was an angry girl who boasted of getting hammered with drink every night, stealing and crashing cars every night, having sex as much as was on offer, and beating up anyone she didn't like. I just happened upon her path on one such 'dislike of all humankind' moments. Locked up in the detention room, she continued with a frenzied barrage of insults.

Spitting at the judge in the Children's Court and calling

him a bastard when she was brought before him, not only
on my charge of assault but also on a string of 24 other
outstanding warrants, did not help Lizzie's case. She was
remanded in custody to Oberstown Detention Centre until
her next court appearance. I accompanied her out to
Oberstown, way off out the country and alien territory to
an inner-city child, and as I lodged her there she told me,
'I'll be escaping from here tonight. You better watch out for
me. I'm dangerous.'

One week later I went out to pick Lizzie up for court.
Miracle of miracles, she was actually smiling, but after
saying hello and getting into the patrol car she put the
guard back up and the tough girl image raised its ugly head
again. 'I'll be fucking out tonight and guzzling down a
bottle of vodka,' she bragged. 'I'll tell that pisser judge
where to go, you'll see.' 'You might want be nice to the
judge, Lizzie,' I advised. She told me where to stuff my
advice. Needless to say I was escorting her back to
Oberstown within the hour as she was remanded again. I
had a more subdued youngster in the back of the car this
time. I don't think Lizzie actually realised that her life was
now in someone else's hands and she wasn't going to escape
as easily as she thought. Bad manners were just not working
to her advantage.

We went back and forth from court to Oberstown each
week. Eventually Lizzie's defences started to break down
until there came a stage where she was waiting inside the
door of the detention centre to show me projects she had
completed that were so good they were put up on display.
By the fourth week she handed me a lovely card with an
apology inside, and lo and behold I could see the little child
in her softening and thriving on the encouragement she
was getting from her minders. The savage Lizzie was gone.
She was being educated; she was eating healthy and she

looked great, hair shining, weight down and she was exercising regularly. It was the first time she had been away from home, where all she was used to was shouting, drinking and battering. Neither of her parents came to most of the court dates. When they did they were drunk and abusive. Poor Lizzie! I liked her. She was smart and she had guts. But what were her chances of survival? I'll tell you what they were. During the time she was held in custody on remand, while the cases were being dealt with, her prospects were fine because she was in a safe environment. Once she was convicted, it was discovered that Oberstown didn't have enough permanent places to keep her and as there was no other female, juvenile detention centre beds, she was let back out on the street again. Within a year I saw Lizzie Connor deteriorate into a desperate, homeless, volatile drug addict.

Once every six months, if even that, the plight of homeless children makes front-page headlines in our national newspapers, because yet another juvenile has been the victim of, or has been culpable in some outrageous crime. The sad reality, though, is that every single night of the year, not once every six months, come hail, thunderous rain or freezing snow, there is a line of homeless children who haven't been fortunate enough to get into permanent full-time care. They have to present themselves to a Garda station so that the Gardaí can ring the out-of-hours social services to try and get them a bed for the night. In the case of Store Street, that could be anything from one to 13 children standing on the steps of the station every night waiting for a social worker. The social worker would sometimes have a bed for a single child in a dingy room of some B & B or hostel, where they would get a bed but would have to be out of the premises by 9 o'clock the next morning. Such children have to hang around the streets

until that evening to go through the same process again because, and here's the problem, they don't have a permanent address and therefore they cannot be given a placement in school!

More often than not, though, a bed might not be available and a child will be handed an allowance to go and get some food. Now what 14-year old knows what's good for them to eat and is going to spend that money wisely? This child will be left to sit on the steps outside Store Street Garda station watching all the drunks and dregs of society being hauled in, or else end up traipsing the streets, vulnerable to all kinds of vice.

I could never understand why, if there were no beds in a house for these children, a marquee couldn't be erected in the Phoenix Park and manned by adults to ensure their security. It would be much better to be lying in a tent, supervised, than to be prey to the depraved minds that roam the streets for such bait. It used to break my heart talking to these kids and to hear the stories of why they ran away from home in the first place. I befriended two of them in particular.

The first was Oisín, a charming young man. Well spoken, he stood out from the others because he just didn't have quite the same street cred. He was more innocent in his manner. My particular friendship with Oisín might also have been something to do with the fact that he was originally from Castleblayney. We had something in common and he could talk about his home to me because I was familiar with the places he was talking about. In a weird way I was a link to home for him, even though he had run away from it. He alleged he did so because his stepfather sexually abused him. The social workers were dealing with the case. I took a shine to him in a motherly way and he would regularly come into the station asking for

me and we would talk. One day I drove him out to Howth Head and we climbed to the top of the hill with my dog. He loved it. His face, looking out over the cliffs at the sea, was one of carefree joy. It was a special day. I realised myself it was an unprofessional thing to do. I didn't need my sergeant to warn me it was dangerous to get too attached, which he did. He also warned me, 'That boy makes a career out of claiming he was sexually assaulted.' Maybe it was because he was, but there wasn't enough evidence to convict not only his stepfather but also the man in the toilets of Bus Áras who paid homeless boys to give him a blow job. Why would a lad of 13 make up those stories? Were they true? I don't know. All I know is that I don't regret showing Oisín that one day of decency; nor do I regret taking the time to talk to him while he was living on the streets of C District. When he moved, he used to leave regular messages for me updating me on how his life was going. Tell Garda Mary I'm doing all right, he would tell another Garda. He turned out good in the end. The last message I got was when Oisín was 17 living and working in Cork, and in his own flat. I often think of him still and send him good thoughts.

I also often think of Laura. She was the opposite of Oisín. She was the queen of the street who fought off foes with ferocity. She wasn't afraid of anyone or anything, or so she would have you believe. Definitely the leader of the pack, she would steer the others to mischief and was involved in many a scrap. She was clever too. She would run rings around me in conversation and in the beginning mistrusted my compliments to her when she would beat me in an argument. I told her she was smart. Maybe that's why she would drop the gang and the hard-woman act every now and again and seek me out on my night-time beat just to have a discussion. It was because of her

mother's new partner that she left home. She felt unwanted and was angry at being thrown by the wayside for him. I watched her grow from street urchin to excitedly calling into me one evening in a uniform herself to let me know she had got a job as a security guard as she had turned 18. These are two of the good stories, but not all of them make it. All that these youngsters are yearning for is acceptance and encouragement. It could work magic.

20

Congratulations, you have been specially chosen to walk the O'Connell Street beat for this, the entire month of June. Please read the following rules regarding beat duty in a public place and adhere to them at all times.

The Ten Golden Rules
1. Ensure that the uniform is worn with pride and in compliance with the regulations of an Garda Síochána Code, i.e. ensure that hair is not unkempt and that shoes are kept polished. Templemore standards are still required from members. Shoddiness shall not be tolerated.
2. Be polite and courteous to all members of the public regardless of how aggressive they may appear. They may simply be having an off day. All members of the public shall be greeted as Sir and Madam . . . with a smile.
3. Always walk on the outside of the footpath where you will be visible to members of the public.

4. Members of the public must be made to feel protected by an Garda Síochána. In this regard, please ensure that you walk with shoulders back and head held high.

5. Do not slouch against walls, particularly when on post duty at the GPO. This gives a bad impression of an Garda Síochána.

6. Under no circumstances shall a member leave their designated beat duty for a break. This includes a break for a cigarette or a cup of coffee.

7. Members shall not be seen to carry unofficial items on their person i.e. it is not good practice to be seen carrying a lunch or personal belongings on the way back down to the station.

8. Members shall walk in a singular fashion while on the beat. There shall be no amalgamating on street corners of two or more members at any time.

9. Have a goal every day. An example might be to talk to the young people who congregate on the median strip of O'Connell Street and ask them why they are not in school.

10. Enjoy this special month.

That was really telling us how to deal with serious crime activity, wasn't it? Obviously this was written by someone not entirely in touch with life in O'Connell Street. Those innocent-looking 'young people' sitting on a wall in the middle of the street were nine times out of ten on the look-out for a naive target to rob. Why aren't you at school then, young sir? I should ask. Fuck off, you slapper, would be their sweet response, but I'd keep smiling as per regulation 2 of the Guide of Good Practice. Yeah, right! Personally, I took the lead of the great Andrew Doyle who seemed intent on following the regulations to the letter.

No one could beat Andrew for compliance. In fact

Andrew was just so scrupulous in his execution of the Ten Golden Rule duty that it was quite impossible to get him to answer a call on his radio if he was engaged in a conversation with a member of the public. Andrew would parade erectly up and down and up and down O'Connell Street. Politeness and gentlemanliness were his two greatest traits. Blindness for the mayhem all around him was another trait, but then that did not come under the ambit of the 'Rules', did it? So he had nought to worry about. Indeed, tagging along with Andrew at night as he would pontificate on philosophical questions whilst walking right by a piercing alarm and a kicked-in door of a business premises was quite an eye-opening experience. Mind you, in fairness to him he did use rasher spit on his shoes. And, boy, did they shine!

Sniffer's shoes didn't shine, but then it was to a different inspector that he paid homage. Our 'abandoned fridges' inspector, I discovered, was not without his own following. He had influenced the minds of many a young novice and filled their heads with the notion that at every turn they must be extra vigilant for terrorists. 'When you get up in the morning and go out to your car, don't open the door until you've had a good look underneath the carriage. There could be a nailbomb put in overnight', he would roar. 'Have the eyes of a hawk at all times, boys, because they're out to get you, now you're a Garda.'

Sniffer had earned his nametag before I got to Store Street, but I was put right when I asked if it was because he had a big nose. He did, but it wasn't. Sniffer had been detailed for duty at the GPO. It's a mindless task which basically consists of nothing more than standing in front of the building. He walked the ring route around the perimeter of the building, down Henry Street through the GPO Arcade, turn on to Princes Street North and back on to

O'Connell Street. Great fun, but still not exciting enough for the junior member who, though only graduated one week, was seeking some action.

He must have heard all the others getting calls on the radio all day long while no one paid any heed to him. He must have conjured up screenplays of heroism in his mind while staring blankly for all those hours. He must have thought his prayers were answered when, on the third circuit of the GPO, he spied an English-registered car with wires protruding from the back seat, parked on Princes Street North.

Panic and exhilaration ran through him that he, Sniffer, had discovered this obvious bomb-laden car. Was it the GPO or was it the Irish Independent that was its target? His friend Fridges luckily happened to be the inspector of decision-making for that day and both revelled in calling in the Army Explosives Unit.

The fire brigade, Rescue and Ambulance were put on high alert. There were traffic diversions put in place and all surrounding buildings were evacuated. Extra Gardaí were called in to cordon off the entire area. My, what a day for Sniffer! His car would be sent up in smoke by a controlled explosion. Commendations all round.

But no. There was neither commendation for vigilance nor was there a bomb inside the car. After all the hoohah including a good car being destroyed, the owner arrived on the scene and declared himself an electrician. His only crime was to park illegally. In this case, it turned out to be a rather expensive parking violation for the State. Sniffer was not left alone on the beat for a while after that!

The rest of us paid little heed to either inspector and we developed our own rules to while away the eight-hour O'Connell Street boredom. A morning shift might start with the nourishment of a glorious bus driver's breakfast in

the canteen of CIÉ, now called Bus Éireann, which could be accessed quietly from a back door on Earl Place, a little laneway off North Earl Street. A couple of hours later the loneliness of walking the beat on our own might get the better of us so we would hook up for a fag and a chat in the Gresham car park on Thomas Lane. The haunts at night might be the Irish Independent offices, which were a godsend in the bitter winter months. Failing entry there, we might just head up to a café on Parnell Street, which technically was the other side of the road from our district but was a great refuge when the nightly leg cramps set in.

On occasion, though, we would be pulled up by the sergeant about our returns, i.e. the number of summonses issued, and on those occasions we would have to get down to the business of actual work. The easiest spot to gain a few brownie points from the upper echelons was an illegal left turn on to O'Connell Street from Parnell Street. One hour there and a member could have sufficient traffic transgressions clocked up that would do him for a month. I was more a 'caution' kind of gal Garda myself, preferring to write all the names, addresses and car registration numbers in the notebook for show to the sergeant. Mostly, I would let the drivers away with a tongue-wagging.

One particular day, after letting ten people go with cautions I decided that the next boy who came around that corner would be summonsed. I psyched myself for action and prepared the spiel in my head. No more nice cop; time to get down and dirty.

The offending car turned the corner and I stood out with my arm stretched up commandingly. It pulled in. The driver rolled down the window and I began: 'Do you know how many signs there are on Parnell Street to indicate that the turn you've just taken is an offence?' Before the driver got a chance to speak, I continued in a rather

condescending tone. 'I'll tell you how many signs there are, sir. There are five signs, sir. Between road markings and traffic signs there are five, sir. I presume you can read.' 'I can,' he replied, and I should have noticed then that his girlfriend sitting in the passenger seat was sniggering, but I didn't. I was on the warpath and this was one driver who was going to receive my wrath. 'Is it a full driver's licence you have, sir? I questioned. 'It is,' he answered. 'Oh, so you passed your driving course then?' I smarted. 'I did,' said he, 'and I passed the motor bike course in Templemore too.' With that, he and his girlfriend burst into laughter. Bollox, I thought, a damn Garda, and blushed as he told me he lived with one of the senior members on my own unit. How would I live that down? Of course I let him go, crawled back into my shell and continued to caution people forgivingly from there on in.

Funny enough, for a woman who had only ever in all my five years in Store Street been detailed for a car once (and true as God, it broke down after 20 minutes), I found myself, out of the blue, being sent on the driving course to Templemore.

There's a distinction between an 'official' and an 'unofficial' driver in the Gardaí and it can be a rather tetchy subject. An official driver is one who has passed the Garda driving course whereas an unofficial driver is any member who has a full civilian driving licence and has been granted permission to drive patrol cars by their chief super-intendent. An unofficial driver would have no formal training whatsoever within the Garda Síochána. While I worked in Castleblayney I would have driven in that capacity.

It has been a thorny subject in recent years, particularly when many of the fatal traffic accidents involving Gardaí have been with cars driven by young unofficial drivers. An

unofficial driver may only drive a squad car when there is no official driver available. There is great rivalry in a station for control of the patrol car, and therefore there is a great eagerness to get on the driving course. The availability of driving course positions has not been able to keep up with the demand for drivers in most divisions. Apparently that is one of the reasons it was reduced from a four-week to a two-week course.

How I got to go on the course I will never know, for those privileges are drenched in politics and kow-towing, neither of which I had the inclination to engage in. Some people are born networkers and know exactly how to get what they want. I'm afraid I'll never win a scholarship into that sector. All the same, influence or no influence, I found myself back in the alma mater once again. I discovered the politics was only just beginning.

The first day we went out in the car, three students to one instructor, the instructor asked each of us where we were stationed. Two of us were in Dublin, the third was attached to a country station. 'You'll be needing to get this course,' said the instructor to the third. 'The pair of you can afford to come back again if you fail,' he said to me and the other Dublin candidate. 'There'd be a load of drivers up there in Dublin, wouldn't there?' Was that a hint of the writing on the wall for my Dublin comrade and me right from day one, I wondered.

I have to say the driving course of the Garda Síochána is fantastic. The instructors are brilliant and the system of driving taught breeds great confidence in the control of a car. The instructors themselves can literally make those babies dance — on two wheels, on four wheels, on one wheel, or if you would like a perfect pirouette they'll indulge you with that too.

I knew they would be good because I have never been

afraid to be a passenger in a car driven by someone who has passed their stringent instruction. In Castleblayney I had complete faith in my chauffeurs even on one occasion when we had a blow-out at 120 miles an hour on the road from Carrick to Blayney. Did I sweat it? Not a bit. My driver held that car manfully. The quick prayer I recited at the same speed may have helped too. Nor was I ever afraid on those breaks for the border that had Northern bucks throw wheel braces or the like out the window in our path when we were chasing at high speed in pursuit. Official drivers were masters of their craft.

Unfortunately I did not achieve the accolade of official driver myself. Nor did 90 per cent of the class for that matter. In fact, what I did receive was an envelope with a stamped page inside which read: 'This is to certify that Garda Mary T. O'Connor 00676K is deemed not competent for the role of official driver.' It was certainly my first certificate of that nature. I laughed that they had gone to the bother of printing such a document.

It was whispered in my ear that the instructors, not having any way to fight the authorities' ludicrous decision (in their eyes) to reduce the course to two weeks, were failing most of the candidates and thereby forcing them to come back for a further two weeks anyway. It was a good trick. However, in my case I reneged on the second two weeks and handed over my next course to an unofficial driver who I thought, after landing a patrol car on the top of the roundabout outside the Point Depot, might just need it more than me. I went back to the beat and the Ten Golden Rules!

21

As a Garda, virtually any time I had to deal with children it was tough, not only because it was almost always a bad thing that had happened, but also because I almost always had to deal with the parents, which can be a far more complicated state of affairs.

Ireland, the land of saints and scholars, has a fantastic education system that strives to teach everyone a high standard of reading, writing and arithmetic. It even spends 15 years on each pupil teaching the Irish language only for it never to be used again. If you want to drive a car in Ireland you must pass both a written and a road test and be a provisional driver first. Every single job has a certain amount of training and apprenticeship. Yet with the most responsible job of all, parenthood, there's not one single bit of tuition given. Anyone can be a parent. Fertility is the only qualifying factor. But what if you add a drink or a drug addiction into the equation? What happens then?

'Charlie Alpha Base to Charlie 75', the station was calling me. 'Charlie 75, go ahead,' I replied. 'There's a shoplifter in

Guiney's on Talbot Street. Will you take it?' 'Roger, on my way.' I went into the back room of Guiney's and there I met the security manager of the shop, who was holding on to a known shoplifter who had several aliases. I had arrested her a couple of months beforehand. She hadn't shown up for court so I knew there was an arrest warrant out for her.

After a while in a station like Store Street you get to know the drug addicts and shoplifters well. Their life stories begin to unravel before you and the longer the acquaintance, in most cases, the less judgmental you become. They're shoplifting, not out of badness but out of necessity to get the next fix. Drugs are all that drives their lives. The addiction has taken over. On the way back down to the station, when I told her I had a warrant for her, she burst into tears and pleaded with me not to keep her in custody. 'Why?' I asked, and so the tale unfolded. Four days previously she had given birth to a junkie baby. The baby was still in hospital because the little mite was born so full of heroin in its system it now had to go through 'cold turkey'. 'If I'm held on a warrant, they'll take her away from me,' she sobbed. 'I have to turn up for her feeding times every four hours. Please, please, I want to be a good mother. Please don't let them take her off me. I promise I'll go back up to the hospital and it's the last you'll see of me. I'm really trying to go straight.' The sentiment seemed so genuine and the eyes were full of the love of a mother. That bond was there even if only in spirit. I'm a big softie at heart. I always want to believe the best in a person and so I released her on a summons with the stipulation that she go directly to the hospital. I warned her that if there was a next time, I would not be so lenient. She thanked me profusely and left. I went back on my beat.

Within the hour I got another call from the station for another shoplifter, this time in Dunnes on North Earl

Street, and there was the bold mother, caught again. As I walked her back in the door of Store Street station another Garda met us. 'You're back,' he said. 'I thought I told you to go home this morning.' It turned out he had arrested her earlier on in the day. I checked the prisoners' list and it turned out she had been taken into Pearse Street at some stage as well and she had used the 'new mother' card on all of us. I suppose the notion that a poor defenceless 3 lb newborn baby was shivering, shrivelled in an incubator trying to 'get clean' hit at the heart strings for all of us. I had no choice this time but to hold her in custody despite all her continuing objections. She turned bitter towards me, that it was my fault that her child was taken away from her. There was no recognition that she held more mass on a syringe than she did her little priceless baby who was fighting it out for her little life in the hospital without a parent by its side.

In her case I didn't actually get to see the child I had a hand in separating from its mother. It's a rotten job but someone has to protect children from such conditions, even if the person cultivating the bad situation has the best of intentions. It is worse again when you have to actually physically restrain a mother as her children are being taken away.

One year, on Christmas Eve, I was working the late shift. Most of the shops close early and there's generally a great spirit of giving and joy around the city. The Garda on the beat even gets a Happy Christmas from passers-by on that day and people sympathise with the fact that you're out in the cold, standing on the beat, while everyone else is racing home for the festivities. 'I'd hate to be you,' one old woman said to me laughing as a light shower of snow started to fall. 'Why's that?' I asked. 'Because by the time you get to be my age, you'll have flat feet, varicose veins and arthritis. Merry Christmas!' she said. 'Thanks a bunch, missus,' I replied,

and thought what a bright future I have. Just as I was wallowing in my own misery, I got a call on the radio: 'C75 can you call up to the cinema in Parnell Street. There appear to be three abandoned children there.'

When I got to the Cineplex I was greeted by a manager who was very anxious to get home and had locked up the premises. He had beside him three of the most beautiful looking children I had ever seen, two girls and a boy, sallow skinned, brown eyed but very cagey. They wouldn't give me any information at first, except to say that Mammy had left them at the cinema to see a film and that she would definitely be back. 'We don't mind waiting here for her. You can go away,' the eldest one said to me. The manager thought they looked a bit young to be out on their own and that's why he had called the Gardaí. He had watched them waiting for over an hour and as it was now 9 p.m. he was concerned. They looked to be about 3, 5 and 8 years old. The eldest took control. 'Mammy will be here. She's just forgotten the time. She's not good on time,' she said, standing in the middle of the two younger kids, one arm protectively around each. 'Does she leave you often?' I asked, and almost too quickly the eldest in a flash answered, 'No, she's a good mother. We're going to have a good Christmas.' Alarm bells started to ring in my head. Something didn't quite add up. I waited with them for almost another hour as the weather got colder and colder and the youngest one's eyes were full of sleep. I could see the older one was willing her mother to come round the corner with every flake of snow that fell from the sky. By 10 p.m. there was still no sign of Mammy and still none of them would divulge their names and addresses. I had to call up a van to bring the children back to the station so that we could look after them, keep them warm and ring the out-of-hours social worker to try and get them somewhere to

stay. In my mind I wasn't that hopeful of them getting anywhere on Christmas Eve night. The only way I could persuade them to get into the van was to promise to leave another Garda at the cinema for as long as it took their mother to turn up, so that he could tell her where they were. 'Don't be mad at Mammy when she comes. She just forgets the time,' the eldest told the Garda that was left behind.

Time crawled by and I tried every way I knew to gain the eldest girl's trust or get the younger ones to give me their names, and it seemed for an eternity I was going to get nothing. As I looked into the eyes of the 8-year old, I instinctively knew from the way she held the others and comforted them that this child had been the one who mothered the other two all their young lives. I suspected that she was the one that looked after the real mother as well when she could. And, boy, had she some blood allegiance to her. She was not going to betray her to us. She would not hear of any bad word against her mother. It was eventually to the carer in her that I implored the name of some other person she might trust, if only for the sake of the younger ones, that they might have a Christmas somewhere other than a Garda station. 'But I'm supposed to light the fire and cook the turkey tomorrow. Mammy won't have a dinner if we're not there,' she said.

As the hours passed, reality dawned that Mammy hadn't just forgotten the time; she had forgotten them also. I got their names. They were very well-spoken young children. And eventually I got the name of a foster parent but no address or phone number.

Just as I was trying to make inroads into who this person might be or where they lived, I heard an almighty uproar in the public office. A woman was screaming at the top of her voice, 'Where the fuck are my children? Give me back my

children.' When I got to the public office, what I saw before me was a woman so drunk she could barely stand. She was a scary looking sight. Detective Garda Sean McAvinchey and I decided not to let her see her children while she was in such a state. Sean was a father himself and I could see it galled him that a mother could dump her kids in a cinema and then run to the nearest pub to get drunk. And it was the nearest pub she had run to. All the time the children were waiting in the cold, she had been just round the corner in a pub on Moore Street. Mothers are supposed to be nurturers. These children were so shrewd in the way they protected her it was obvious this was not the first time this had happened. It was sad to see children having to be so grown up at such an early age.

We questioned the mother who became even more abusive. The tears and the curses and the unmerciful screams out of her were heard throughout the station, so naturally the children were going berserk thinking we were torturing their mother. We weren't. She knew if she caused a big enough racket we would give in to her. We did. We had to let them see each other then. Reunited, it was plain as day they loved each other, but when the mother picked up the 3-year old she staggered across the room, banged into a table and let him fall on to the floor. It was obvious she wasn't fit to be looking after them, not at that moment anyway.

Eventually, through the social services we discovered the phone number of the foster parents and rang them. Apparently the mother had a massive drink problem. She was also a resident of Portrane Psychiatric Hospital and had been let out for Christmas. The foster parents had only handed over the children that morning to spend Christmas Eve and Santa Claus night with their mother. They were to collect them the next day.

I have a great mother and her birthday is on Christmas Day, so that day is a double celebration in our house, a Christmas cake and a birthday cake. We always got the best of presents and Christmas Eve was always the most special night, going to midnight Mass in Summerhill church, Co. Meath, and listening to Mrs Lynch's angelic choir. My mother was a rock, always at home, always with good advice, always one hundred per cent out for our welfare and utterly selfless. There was no question but that our existence and our happiness meant everything to her and her whole world evolved around her children. I was lucky.

Taking those children from their mother that night is a memory that is imprinted in my mind for ever. The mother pleaded, screeched, cried and pulled on the sleeves of those children. We had to literally drag them out of her arms. After we got them out to the car I could see the mother lying prostrate on the floor, heart broken. She had managed to make the children think they were abandoning her. We drove them to meet their foster parents, who turned up with teddy bears for the two youngest. At 2 a.m. on Christmas morning we handed over three little angels to a safer haven than their own home, and as we did so the eldest took my hand and said, 'You look after my Mammy.' 'I will,' I promised

I went back to the station and Mammy was on a suicide watch as she had picked up any and every object there was to do herself harm when we left. I sat with her all night waiting for the ambulance from Portrane to pick her up. As she began to sober up she began to talk. Behind the obnoxious drink-swilling, foul mouth, there appeared a broken soul who had made a million efforts but just never got it right. 'The only thing I ever did right was have those children. I only left them to go and buy their Christmas presents, but I couldn't pass the pub,' she said. 'What do you

think, Garda? Do you think I need help?' 'What do you think yourself?' is all I could answer. In the end she wouldn't go into the ambulance unless I went with her. She had big, sad, tearful eyes and clung on to my hand for the whole journey. When the nurses came out to bring her in, she had to be dragged away from me. I gave her a hug and told her, 'This is the right thing to do. Get strong and get your children back.' As I drove home from work in the early hours of that morning, I turned on the radio to break the sadness of that family torn to bits and heard the words, 'Merry Christmas to all and to all a good night.' I went to sleep exhausted and emotionally completely spent.

Such is the life of a Garda. I have the power to question mothers about the unspoken tortures in their hearts. I can escort people to psychiatric hospitals. I can push people right to the point of admitting horrendous actions. I deal with the worst of the badness, the black pit of the sadness, and then that's it. They're gone from my hands. I have no part in the cure. I may never see that person again, but there is always a trace left behind.

22

Even when parents are trying the best they can, things can still go drastically wrong. One night as we were cruising around Sean McDermott Street, we spied a couple of teenage girls who not only looked out of place because of how well they were dressed but appeared to be hanging around waiting for someone. That someone, we suspected, was a dealer. We were right. A guy, known to us, passed their way and there was a definite exchange between them. We picked up the two girls and after a search found a couple of ecstasy tablets.

We brought them back to the station and proceeded to call the father. Gobsmacked, flabbergasted, astounded disbelief doesn't even begin to describe what their Daddy felt. The girls lived in the best address in Killiney. They were 13 and 14-year-old sisters. Daddy had done his utmost to ensure the safety of his girls. He had driven them to the door of the SFX Centre as they were going to a concert there. He watched them go in the door and he was to collect them at the door when the concert was over.

The conniving daughters waited until Daddy's car was gone, scuttled out of the sFX Centre, made their way to McDonald's on O'Connell Street, asked where they could get drugs and were told to hang out on Sean McDermott Street. They followed the directions. The danger of loitering around a dark, dingy street that is host to many unsavoury characters didn't even enter their little heads, not to mention the death wish of accepting drugs from an unknown source. How does a parent win? Parents do not have an inkling of what their children get up to. If they did, they wouldn't let them out of their sight for a second.

Drugs are everywhere. The lure of them spans every social group in every town and village in the country. As a Garda in Store Street I'd say 80 to 90 per cent of the prisoners who came in were drug addicts. It was so sad. Even in my short time there I witnessed the physical deterioration of so many poor souls.

I recall one girl from the Dun Laoghaire court from the time I was a student in Blackrock station. She particularly stood out that time because I remember thinking, how did a model like her get involved in robberies? She was stunning looking, long dark hair, beautiful features, over six foot tall and willowy. I'm sure any model agency would have put her on their books without hesitation. One year later she was dragged into Store Street station totally strung out, incomprehensible, her hair falling out, horrible scabs on her face and her bones sticking through her skin. I was astonished at her condition. How drugs ravage the body!

If I was an educator I would bring every secondary school student to Store Street at six o'clock in the morning and open up the cell door of an addict who has been in there all night. The knock-out, vomit-inducing stench that overwhelms you, as well as witnessing the disintegration of the body after the prolonged use of drugs would be enough

for them to at least question starting the dreaded vice. Of what use is having a reformed drug addict talk to kids? That, to me, only sends out the message that you can abuse your body as much as you want, but you will come out of it OK in the end. God, if kids could see how much that is not the case and how desperately vulnerable an addict is. It is the drug addicts in the middle of their tortures that should be giving the talks. That would be a real disincentive.

At one stage while I was permanent gaoler I decided I would conduct my own private survey and ask all the female druggies I had to search every day what age they were when they started drugs. The average was 12 years old. Twelve years old injecting heroin! Can you imagine a normal child of that age even knowing how to use a syringe? How could they be right ever again when they're destroying what little tender brain power they have? All of them said that if they had the chance again they would never touch drugs. All of them, though addicted, regretted the situation in which they found themselves because of drugs.

The bodies of some of the women I have seen during searches were stomach churning. One girl peeled off her jeans and a fountain of pus sprayed out from an open wound on her thigh. It was gangrenous and you could actually see through to the bone. It had never dawned on her to get medical attention. She didn't think herself important enough. Abscesses for her were normal. She hadn't even noticed this infected lesion on her body.

Another guy I arrested for being drunk and disorderly one night told me to 'mind the tumour on my head'. When he turned around there was a big bulbous tumour hanging out of the back of his skull. I had a long conversation with him that night he was brought in. As it turned out there were warrants in existence for him. He told me he had been

the first prisoner arrested with AIDS in the eighties and that Mountjoy Prison had no idea how to deal with him. He said they left him sitting on a chair in the middle of the foyer for hours with newspaper on the ground all around him, obviously while they deliberated on how best to approach the situation. When they eventually came to log him in, the two prison officers had donned white suits. They left him in isolation for his stay. He was the walking dead when I arrested him and he did die within a couple of months of our encounter. I was sorry I took him in.

But many of them offer themselves up for arrest knowing there is a string of warrants out for them. They would willingly go into Mountjoy when it's all getting too much for them. The Joy gives them the opportunity to get their strength back up again. This happens more frequently around Christmas because it's such a lonely time. They would be looked after inside. Isn't there something wrong with our system that our prisons are a more pleasant environment than home?

I have seen some of their homes. One drug search I was involved in at St Mary's Mansions defied all sanitation regulations of even the poorest Third World countries. We pushed the door in and were immediately stifled by the horrendous, choking, foul smell that hit the nostrils. Never mind the state of the place, which you would swear had just been turned over by thugs, or even the dirty syringes on the floor that had to be stepped over. But there, in the middle of the sitting room, was a barrel that was being used as a toilet, full to the brim with human faeces. As a farmer's daughter I have seen slurry pits and slatted units and smelt many animal smells, but you wouldn't have put a dog into this flat and yet a family was being reared in it. Yes, I'm against drugs because I've seen the devastation they cause.

A lot of the druggies that come into Store Street are HIV

positive. Most of them will tell you they are when you're searching them and most of them will let you know if there's a needle on their person and warn you to be careful. When druggies are craving the next fix they're usually fairly co-operative. They know they can ask for a doctor and get Physeptone. This is usually a good time to question them. They'll give all and sundry away waiting for the Phy. Strung -out drug addicts have no allegiance.

However, when you catch them on a high it could take six strong men to restrain an addict. One prick from a needle could be a death sentence to a Garda and a plastic glove is no protection against getting a nick. It is a huge concern for Gardaí these days. I don't personally know any Garda who has contracted HIV in this manner, but I do know several that have had to wait out three months of horrific anxiety after being assaulted until they were eventually passed clear. Thankfully it has never happened to me yet.

Of all the specialist units there are in the Garda Síochána I have the greatest admiration for those who sign themselves up for the Drugs Unit. At one stage I worked as crime clerk in Store Street and had an office opposite theirs for a year. I watched as they planned, went under cover, endured cold night-long stake-outs and took down a lot of drug barons in the area. They are without exception the most dedicated Gardaí in the country. It's a 24-hour job and therefore not one conducive to family life. It's probably not a job any Garda would sustain for more than five years either as it requires social sacrifice and tremendous commitment.

Patience is an essential requirement. Could you wait for two days or more for a human carrier to defecate into a bucket and then have the stomach to wade through the excrement for a bag of drugs? Didn't think so. Up until the new station was built, this was part of their remit.

Technology is more advanced now. Now the waste is all held within a vacuumed unit, almost like an incubator, but you still have to poke through it manually, albeit with a sealed glove. Could you be paid enough to do that?

I did have a few drug catches in my time in Store Street, nothing comparable to the Drugs Unit, but one in particular sticks out, not because of the drugs either but because of one of the characters who was arrested at that time.

Some of the late-night haunts of our district were dens of iniquity. Reports of under-age drinking, under-age sex, assaults and drugs were rife from these establishments. Another Garda and I went into one to check for under-age clients. What we came out with were two males and a female who had over 60 ecstasy tablets in their possession. They had obviously been dealing inside.

In the Gardaí you develop a gut instinct for the ones that are lured into something beyond their control, either through plain stupidity or simple innocence, or trying to impress someone else. You can tell when you have caught them out of their natural zone, that they are doing something out of character, or at least you hope you can. It was quite obvious that the two boys in this case were from pretty decent families, and I quickly add that that in itself does not mean any better treatment from the Gardaí. They were both studying in IT colleges in the country. They were devastated at being caught and I have never seen such remorse. The girl, on the other hand, you would swear had not a care in the world. The arrest was like water off a duck's back. If anything, she revelled in the notoriety it would bring.

I interviewed all three separately and it transpired that each of the guys considered the girl to be their girlfriend. I had to laugh because a half-hour before I talked with them,

two other boys had turned up at the door of the station looking for what they thought was their girlfriend as well! She was a goer all right!

All three were brought to court on charges of possession with intent to supply. The District Court judge refused jurisdiction because of the seriousness of the crime, so it was sent forward to the Circuit Court, a higher court that can bestow longer sentences. It was around the time of a lot of media coverage into the tragic deaths of a couple of teenagers in England from taking ecstasy. Judges were showing zero tolerance. That terrified the two boys. In the meantime a probation report was ordered.

I had a word with all three after the first court date. 'Do yourselves a favour and keep out of trouble. When you go to talk to the social worker be very polite and for God's sake tell her you've mended your ways,' I advised. By the following court date it appeared the boys had seen the light. Salvation was theirs. They had impeccable attendance reports from college and had not dabbled in bad company since. 'And what about the girl?' the judge enquired. The probation officer wiped her brow and began with a sigh. 'Well, judge,' she started, 'the lady in question did not turn up for the first three appointments. On the fourth appointment when I asked her was she off the drugs, her reply to me was, "My philosophy of life is *carpe diem* [seize the day]. I intend to get as high as I can, for as long as I can, whenever I can. I intend to sleep with as many boys as I can. I want to party as much as I can and have fun, fun, fun."' The judge gave her two weeks to reassess her and remanded her for a further probation report. She laughed loudly and told him, 'I won't change you know', as she left the courtroom.

I have to admit somewhere in the back of my mind I had a little bit of admiration for this girl. You had to hand it to

her. She had guts, even if it was misplaced. She had such a happy smile I could see how she could have enticed the boys into her mad, zany, don't let anyone tell you what to do world. It certainly had a wily charm. Unfortunately, life does not let you away with putting the two fingers up at convention and unfortunately this happy monkey didn't even get her opportunity of a court sentence for rehabilitation. She died of an overdose before the two weeks were up — no doubt with a big grin on her face. The boys got the Probation Act. And wasn't it a lucky escape?

23

For the latter part of my time in Store Street I was more or less permanent gaoler for my unit. What that meant was that I was run off my feet for the entire eight hours of each shift. The job entailed answering phone calls, answering the radio, clocking in and processing prisoners that were brought in by other Gardaí, advising young recruits on legal procedures and dealing with members of the public who called to the station with complaints.

For the heck of it, one day I decided I would actually count the amount of questions I was asked during the course of one shift. It is no lie to state that on a busy Saturday a gaoler could answer in the region of 300 requests during one tour of duty. At the end of the shift the brain would be decidedly addled, but it was much better to be busy than not.

It was a hectic position but one I was good at. Yet, no matter how competent you think you become, no matter how many right answers you give, there is always that one

query from someone who calls to the counter that is guaranteed to take the wind out of your sails and stop the express in its tracks. 'Can I talk to you in private please, Garda?' Those few words always, always meant the disclosure of a very grave offence, or so, in my experience I have found, particularly when that someone is a woman. Invariably it would turn out to be a report exposing some sort of sexual abuse.

I wish we all lived in a utopia where there was no such thing as rape, paedophilia or sexual assault. I wish we lived in a world where everybody had respect for each other. I particularly wish that no man, woman or child ever had to suffer not only the actual trauma of being a victim of sexual perversion but the life-long sentence and psychological damage that all those cases involve. But unfortunately real life is not like that. Even after reporting them, most cases do not reach a courthouse.

'Can I have a word with you, Garda?' a fresh, freckled-faced girl with a big smile and three kids hanging out of her, asked me one glorious summer afternoon when I was confined to quarters behind the counter of the public office, contemplating taking a half-day's leave so I could avail of the sunshine and top up my holiday tan. 'Of course,' said I, and led her to an interview room down the corridor. 'What's the problem?'

She was a pleasant young slip of a thing, not up to my shoulder but about the same age as myself. The three children were well mannered and happy looking, like herself, or so it first appeared. She lived in a flat complex in my district but was not a Dub. She was from the south of the country. Within seconds, once the door was closed, the smile vanished and her tale began to unfold.

She was reared the eldest of five girls in a family. The father had been in and out of their lives many times, so the

three eldest were close in age but there was a big skip of ten years and more to the two younger girls. The father was a drinker and when things would get very violent at home, the mother would take out a barring order against him. Every so often she would relent and take him back into the house.

At the age of 11 this girl had made a report of rape against her father to the Health Board. A social worker and Garda had taken on her case. It was on one of these occasions that the father had been thrown out of the family home, but not long afterwards the mother took him back in again and the girl was persuaded to retract her statement.

The abuse continued and even moved to the sister who was next in line. Her sister also made a complaint but in a similar fashion that was also withdrawn. The abuse continued and the woman who was talking to me made another report to the Gardaí, but this time she ran away from home and sought refuge in Dublin.

The years went by. Every now and again the girl's mother saw sense and threw the offending bastard out. The harmony lasted for six years but the mother, who by this time had become a drinker herself, took him back in. My girl was now concerned for the safety of her younger sisters who were reaching the age that the abuse had started with her. 'What can I do?' she asked.

I sought counsel and was advised to take a statement from her, but that it would have to be passed on to the Gardaí in her home place for investigation. I took the report. But before sending it through the channels I decided to check from the local Gardaí exactly what the family's situation was. 'Oh, don't talk to me about that family,' one Garda said. 'They're a nuisance. There isn't a week goes by without call-outs to that house. The father is a tyrant, but sure the mother is as bad.' I tracked down and

spoke with the female Garda to whom the abuse allegations had been passed on. 'You don't want to open that can of worms,' she said. 'It's a messy one. It's better left at the bottom of the pile.'

I was disappointed with my peers. How could they leave defenceless little girls to the mercy of such a pig just because it would be too much work to unravel 'the mess'. My detective inspector was equally outraged and sent a snorter in his order for a thorough investigation into the case. I pray there was some justice for my girl, but I doubt it.

Abuse cases are always complicated. They are always difficult. I suppose from the point of view of a Garda they are not nice to deal with and you cannot but be affected by them. It is strange though, for as much as you may have empathy with a victim of abuse, the questions asked of them must initially try to discredit their story. As a woman, it is not easy trying to disprove an allegation from someone you think is telling the truth. But there is good reason for following this procedure. Some of the allegations I have received as a Garda were blood curdling, until after investigation, as was the case with one youngster, it was discovered it was nothing more than the product of her vivid, sick imagination. The young under-age teenager in question was either afraid to tell her parents where she had spent the night, or afraid she had become pregnant, or had got herself into a situation that was uncomfortable for her.

This case was one to which I gave a lot of time, energy and emotion. A call came from the Rotunda that there was a 13-year-old girl at the Sexual Assault Treatment Unit there who was alleging she had been raped. I was dispatched. I got to the unit and a woman from the Rape Crisis Centre introduced me to a middle-aged man and woman and another young woman. As I greeted them I wondered

where my victim was. As it turned out I was looking at her and her parents. I couldn't believe she was only 13. She was 5 foot 8 and from where I was standing would have easily passed for 21.

She alleged that two men had pulled her into a laneway the previous night. There were two more waiting in the lane and she claimed all four raped her, after which two of the men urinated on her. She said that after it happened she had been too afraid to move and fell asleep on the ground at the scene of the attack. When she awoke, she rang her father, told him about the shocking assault and he went and picked her up. It was a horrific story and she appeared totally dishevelled and shocked. She cried. She was barely able to talk for what appeared to be fear and trauma. My heart went out to her.

The investigations began. I and a team were put on the case. Forensic evidence was obtained and the scene was preserved. Litter bins were sifted through. Hours and hours of CCTV footage was viewed to see if I could place this girl or the four culprits at the scene. As the tale unfolded it transpired our girl was not so innocent. She had been out drinking in a pub with her sister and friends the night before. Further investigation suggested she had been seen taking drugs and that a male friend of hers had walked her to a flat complex and left her with another young man whom she appeared, he said, 'to know very well'.

Forensic results started to come back which showed there was only a trace of one sample of seminal fluid. The girl had had sex, but with only one male. The girl stuck to her guns for a long time until the evidence given by her in her initial statement was disproved several ways. Eventually she broke down and admitted all. She was a regular drinker, it seemed, even at 13. On the night in question she had had five pints, smoked dope, had gone to an ex-boyfriend's

apartment, had sex with him and had concocted the whole story because she didn't want to be reprimanded by her father for staying out all night.

There were 25 lengthy statements taken in all. The young man admitted having sex with her, but his defence was that he believed her to be a lot older. Because she was a minor, technically it was unlawful carnal knowledge on his part and therefore a file was sent to the Director of Public Prosecutions to see whether to charge him or not. He wasn't the most reputable of characters and certainly if I had a daughter of my own I wouldn't want her to be going out with the likes of him, but I do believe he genuinely considered the teenager to have been older. He tried to commit suicide before we got a direction from the DPP *not* to prosecute him. How dangerous false allegations can be?

In fact, the final recommendation from the DPP's office requested that the girl be cautioned with wasting police time. She was. An unfortunate aspect of the case was that the parents were separated, living in different houses, and neither had actually missed the girl that night. The whole story need not have been concocted in the first place. The public seldom find out about incidents such as these when they talk about the work of the Garda Síochána, but there is a lot more work than even this entailed that goes unnoticed.

24

The first time I arrested a man with the letters ACAB tattooed across his knuckles, I had to ask what it stood for. 'All cops are bastards, stupid!' I was told. It was the first realisation that it didn't matter how fair or humane I was, I was going to be branded under a blanket hatred because of my uniform. There are just under 14,000 Gardaí in this country. Are we all bastards?

Blanket, preconceived notions of people because of association are all too common. Ironically, it is precisely because I am a Garda that I have come to be less judgmental of people because of what they wear, what they look like or which social grouping they belong to. I wasn't always, but I came to realise that there is one sure thing when dealing with the general public: people *always* surprise.

One night I was working in the Garda office in O'Connell Street. It is the central office that houses the CCTV cameras that cover the city centre and its environs. The wall is smothered with monitors that cover every angle of every

street in the area. This night was a particularly quiet one with not much to observe. On Liffey Street a pigeon on the ground caught my eye.

The office was a good resting spot for the tired beat-men, so there was a crowd of us gathered watching this injured pigeon. Its wing was hanging askew and it failed several attempts to get airborne. A jocular discussion ensued as to which one of us would take out a car and run over the bird to put it out of its misery. The rescue of such an insignificant species would have been too bothersome and didn't even enter the debate. How best to kill it rendered many suggestions. The overwhelming conclusion was that we would do it if we were sure we wouldn't be seen.

As the conversation got more and more gory, I spied in my monitor two guys make their way on to Liffey Street. These guys were body-pierced, leather-clad, tattooed, tough-looking creatures. We'll have trouble here, I thought, and called my comrades to adjudicate. The men strode in a masterful manner down the middle of the street. All who came their way passed sheepishly at a distance. They looked like men out for a fight, we all thought, but secretly prayed that none of us would have to encounter the beasts in combat.

The hairy ogres caught sight of the poor bird and made a bee-line towards it. 'One kick of those Doc Martens should do it', someone said, and we all erupted in laughter. As we guffawed, a miracle transpired before our eyes. One of these giants knelt down and gently petted the pigeon's head with his forefinger. He picked up the frightened bird and nestled it into his bent elbow. The two men continued up the street, all the while soothing the pigeon. I was so intrigued by their show of gentleness that I positioned the cameras to catch their every move and I followed them up Henry Street, turn on to O'Connell Street and make their way right up to the

door of the Garda office. They rang the doorbell. I beckoned them in and as one of them asked for the number of the ISPCA, I swear I detected a little tear in his eye. Their concern touched me. I got a box for the bird, kept it in the office and nursed it for the night until the ISPCA collected it the following day. The bold bikers with the St Francis of Assisi hearts changed my hasty judgment of people for ever after that. Unfortunately, not all my colleagues came to learn such a lesson.

What instantly springs to mind is a colleague I worked with in Store Street who had no time for black people. He would spy them *en route* to the station and as they were making their way through the door he would turn to me and say disdainfully, 'You deal with that. I'm not dealing with that.' He didn't want to know. He could just as easily say this in front of sergeants or other Gardaí and not one would take umbrage at his blatant racism. Another member I worked with would deliberately throw buckets of cold water on top of any strays, and I'm not talking about dogs, who settled on the steps outside the station in the early hours of the morning. 'Cleaning out the riff-raff', he would say. 'Can't let them know you're a soft touch.'

Now most Gardaí I know are decent people with healthy and interesting hobbies. I know Gardaí who are expert film buffs, wine connoisseurs, masters in Reiki, football managers, marathon runners, farmers, carpenters, stamp collectors, antique dealers and anything else you care to mention. Gardaí are just normal folk doing a job. There are, of course, exceptions. Just as there are in any organisation of its size, there are rotten apples in the barrel. It's the bad eggs that breed the need for such tattoos as ACAB. And yes, some of them are bastards!

We Gardaí hold a unique position in society. We are the guardians of the peace and duty bound to uphold the law

and protect life and property. Most new laws dictate the precise powers given to the Garda Síochána within the Acts, but there are always some anomalies, for instance a Garda's powers of discretion or the degree of force permissible in the course of carrying out their duties. How do you standardise discretion? To empower someone to use discretion automatically assumes that that someone has a fair and logical mind to begin with. What if not all of us do?

As a Garda, in certain circumstances I have discretionary power to make an arrest or not, to summons a person to court or not. Say, for example, I'm on night duty and I see a young man falling around the street drunk and shouting obscenities. When I approach him, he roars at me. I have a choice: I can arrest him straight away for several public order offences or I can tell him to cop on and go home. Either choice is acceptable in law, but here's the rub. My choice could be dependent on several factors. Do I have the inclination to spend at least an hour processing a prisoner by the time I have all the necessary documents in order? Has the superintendent just sent a snotty letter to my sergeant criticising my work return and demanding more arrests? Am I swamped with a load of other work with too little time to do a proper investigation? But the biggest factor of all might be that unwritten rule amongst us Gardaí — has this person passed that initial '10 second attitude test'?

If, on the first encounter with a Garda you happen to say, 'I pay your wages', that, I can guarantee is a definite failure of the golden rule. As is 'you're only a souped-up civil servant.' Likewise 'have you nothing better to be doing with your time, Garda? You should be out there catching the real criminals.' 'I'm very sorry, Garda' as an opener will, at least, bring you to the negotiating table and allow me to use my discretion. But then I am a mild tempered person; not so

some of the colleagues I have worked with.

It's the same with the use of force. Of course there are occasions when brute force is required to restrain or apprehend people. But my threshold of where to stop with the force might be a lot different from someone else's. It's an area where a lot of Gardaí differ. My general hard and fast rule is that if I have got a prisoner in handcuffs I don't feel the need to give him or her a few slaps. Nor do I generally feel the need to use his or her head as a door opener when I get back to the station! Others do.

In all my time as a member of the Garda Síochána, I have only ever had one lecture on moral ethics. It was during phase v when my class had been Gardaí for a year and we were called back to Templemore for our final six weeks. During the course of this lecture one of the, by then, seasoned male Gardaí disrupted the class calling it a load of codswallop. He said that when he had a row with the missus, of course he was going to vent his anger on prisoners. Wouldn't that be better than beating her to pulp? He received no reprimand and passed the grade with flying colours.

We walk the street and what do we have for protection but a light wooden baton. As one experienced Garda in Castleblayney, who never bothered to bring it out in his pocket for 25 years, put it: 'Mary,' he said, 'if you ever get into a situation where you have to go for your baton, you're in more severe trouble than a bit of wood is going to solve.' However, there are times during the normal course of daily duty that deep down there is an unspoken fear: fear of getting a stab from an infected needle; fear of approaching a drunken or drugged-up mob that couldn't care less about the uniform and are only waiting for action; or fear of being lured into Sheriff Street or some such place and being barraged with stones.

If you put all these ingredients together — inadequate protection, daily reports of fellow colleagues being assaulted, no direction from the authorities as to what exactly the proper use of force is — and add testosterone, personal angst and hatred into the big melting pot, what are you going to get? Of course you're going to breed some powerful assholes!

Many years ago when I attended Athlone Regional College as it was called then, I distinctly remember going to a party one night held by a fellow classmate in his rented house. There were mostly lads at this party, all intelligent and for all of whom I had great respect. Midway through the party one of the boys laid into another, accusing him of both robbing a tape and being a gatecrasher. Six guys jumped on the poor unfortunate and when they had him pinned to the ground they kicked him in the head while another grabbed a steak knife from the kitchen drawer and lunged at the victim. Thankfully he was stopped. What shocked me that night was the manner in which some of my so-called respectable pals lashed in for the row, fighting dirty, whilst others among them remained calm.

It's much the same on the beat, and as a female it can be particularly hard to control the outcome of certain confrontations. In such a lowly position I was regularly jeered at for even questioning the behaviour of some of my co-workers. Wanting to talk with, rather than goad a prisoner into a fight, was seen as being a big softie.

There was one occasion when I was called to Penney's in O'Connell Street. Security had stopped a shoplifter. He was a big guy in his mid-twenties, but when I saw him he was cowering in the corner of the back room. 'I know I did wrong,' he said. 'I will go to the station with you but don't touch me.' I went to take him by the arm but he became nervy and extremely distressed. I backed off. 'I told you.

Don't touch me. I have a phobia. If people touch me I will lose it. I will go mental. I promise I'll come quietly if you don't touch me.' He walked out of the shop like a lamb, but as we approached the patrol car two Gardaí jumped out to put him in the back seat. Just as I was warning them not to touch him, one of the Gardaí grabbed the prisoner by the arm. All hell broke loose. The prisoner, true to his word, went berserk. 'Urgent assistance required', was roared into the radio and within two minutes six Gardaí were at the scene and my prisoner had a broken nose and a badly bloodied face. After my manly crew dumped him into the cell I went in to talk to him. 'I told you I don't like being touched,' he cried and curled up in a ball on the bed. 'I'm sorry we hurt you,' I said to him. It turned out he was phobic and on medication for paranoia. He didn't cause the slightest problem for the rest of his stay. My crew were justified in their actions because the prisoner had become violent, but just a moment of listening in the beginning would have gone a long way in preventing blood being spilt and bones broken.

I'm not for one minute suggesting that we try a girlie girlie approach to policing. Obviously that would be a disaster in crisis situations, but there is a difference between zero tolerance conducted with fairness and zero tolerance conducted by blinkered, stubborn mules, some of whom go to work looking for a fight. And, just for the record, we of the fairer sex are quite capable of piling in when needs be. I have myself made and witnessed my female co-workers make many a good rugby tackle or give a knee in the groin when the occasion required.

In the male-dominated world of the Garda Síochána there can be a tendency on the part of some women to behave in a macho fashion, trying to prove they're as good as the men. It doesn't work. One night another female

officer and I were walking the beat together. On Liffey Street we spied a drunk urinating against a shop front. The other Garda looked at me with a grin and said, 'Come along and watch what I learned last night from one of the lads.' I followed. She lambasted this guy from a height. She lectured him on his immoral behaviour and admonished him about the fact that some poor shop owner was going to have to wash his urine off the door in the morning. 'You wouldn't like washing someone else's piss off your front door, would you?' she chastised. Then she winked at me. 'Take off your shirt and clean that door,' she commanded. The drunk told her to fuck off. 'I'm telling you one more time to take off your shirt and wipe down that door,' she roared. He again told her what to do with herself. I could tell by her reaction that this scenario had run a lot smoother the night before. Several more times she made the demand, but he was stubbornly defiant. My friend was not going to be beaten. In the end she had no option but to make an arrest and called a van for him to be hauled up to the station. 'That's one big lesson I've learnt,' she said ruefully. 'That's the last time I'll try to copy the boys.' Playing tough is hard work especially when it's out of character, and just like a horse smells fear, so too does a wrongdoer sense underconfidence. Mind you, it's not always out of character for all the females.

On another night a different female officer and I were manning the public office. A couple of colleagues arrested and brought to the station two travellers for a drug search. The two were taken to the cells and searched. Nothing was found on either, but there was a warrant in existence for one of them, so he was retained in the cell. Meanwhile the other was let go. As he left the station it occurred to him that his partner might need cigarettes or food for the night, so he came back into the public office to ask if he could get

some things for his friend in the shop. As he stood there mid-request, my esteemed colleague took a canister of air-freshener in her hand, sprayed it smack bang into the face of the traveller and shouted, 'Smelly knackers! There's an awful whiff around here even this wouldn't get rid of'. That moment is one of those very bad Kodak moments that I will not forget. Her exhibition astonished me, never mind what it did to the innocent man standing before me. I was disgusted. This ignorant act brought my fellow female Garda right down in my estimation after that. How dare she, I thought. Who the hell does she think she is? The man would have been well justified in making a complaint. He didn't. Sure, wasn't he used to such insults, being a *knacker*? I expressed my revulsion straight after this occurred. Typically, nothing was done.

Knackers, gougers, blacks, refugees and almost every minority group there is come in for a lot of negative comment and rough treatment among some Gardaí. No one I know beyond probation has ever been censured for it, so it is allowed to fester. Unsurprisingly, the old respect for the uniform has diminished in its wake.

25

You have to laugh at people all the same. Being in a
job that deals with the public even though it's often
viewed as an austere profession, there are many
wacky interludes. For some reason the public believe they
can ring a Garda station at any time of the day or night and
use us as a substitute for taking out an encyclopaedia or a
telephone directory or making a visit to the doctor's
surgery. Honestly, some people think 999 has the answer to
all the obscure questions of the universe! We can forecast
the weather. We can tell what the hot tips for the next race
meeting are. We all have ten tickets for the next All-Ireland
Hurling final sitting in our back pockets and we can solve
the personal problems of every drunken woman who gets
lonely for a chat at four o'clock in the morning.

'Why did my boyfriend leave me?' Well, if you're ringing
me, a complete stranger, and giving intimate details of your
sexual behaviour over the phone, I'm not bloody surprised,
Missus. 'Will my car start for me in the morning?' Is there
any reason it shouldn't? 'Well, my friend's car didn't start

for her this morning.' How do you answer that? Where's my cat? How does the red dust get here from Africa? Is my husband still in the pub? These are only a small selection of the ridiculous questions Joe Public desperately requires the answers to at ungodly hours. I think the best one has to be by the guy who rang up and asked me one night, 'What's the name of the book my friend wrote but it never got published in 1956?' You just hold on there, Mister, and I'll look that one up on the Garda computer!

For some reason, while attached to Store Street, I always seemed to be working during the full moon on my week of nights. I have a vague memory of reading somewhere that in New York there are extra cops put out on the streets to deal with the added lunacy during a full moon. With each passing month I became more and more convinced that the light-headedness caused by the full moon's gravitational pull sent out a secret mantra to the mad and sad people of Ireland. 'Make your way to O'Connell Street. Make your way to O'Connell Street.' For they did. And in droves.

I also began to wonder at my sergeant's opinion of me because he always detailed me to deal with anyone who was mentally a bit left of track. Was it because I was a woman or was it because he believed me to be a little odd too and therefore on their wavelength? Perhaps a bit of both, or perhaps he felt I had the patience and a sympathetic ear for miserable or deranged ramblings.

There is an infamous tale in Store Street of the callous Garda who was detailed on a post at the GPO. When a member of the public frantically ran to him looking for help because there was 'a jumper on the bridge', he calmly turned to the distressed person and said, 'If someone wants to kill themselves, well that's their own prerogative, isn't it?' and stood fast in his post. True story. The person has since

left the Gardaí. I was a little bit more of a people person than that, thank God.

Every month, on my weeks of nights, I came across one particularly sad case. One week I would have to try and save him from running out in front of a lorry. The next he would be standing on the banks of the Liffey about to jump in. Another week I would end up talking to him after he had been pulled out of the Liffey, and yet another he would be wildly brandishing a knife and threatening self-harm. Without fail there was some attempt at suicide each month — so much so it became comical. One night as I was sitting on the floor beside him in the station asking about his life, he listed several other methods he had tried over the years. He had been hospitalised for anorexia and overdoses, not to mention jumping out of second-storey windows. I asked him how long he had being trying to kill himself. He answered, 'Twelve years.' 'You're not very good at it are you?' was all I could respond.

The night of the full moon brought with it a strange atmosphere and arrests or detentions of unlikely specimens. Etched in my mind forever is the vision of a middle-aged woman from the south who was brought in because she felt the compulsion to moon at passers-by right in the centre of our nation's capital city. She pulled down her panties whilst dancing on the 'Floosie in the Jacuzzi', a fountain statue of James Joyce's Anna Livia Plurabelle. You could tell instantly that this was not normal behaviour for this woman. She was expensively dressed, wearing pure silk underwear, a cashmere sweater, designer skirt and donning a soft leather Gucci handbag. Her foul tongue belied her respectable attire. Every male Garda that passed the door of the detention room got an eyeful of a gloriously lush bosom or meaty thigh. The sergeant was given a very special treat of his own when one of the bosoms turned out

to be a false boob that was slung smack into his face. This woman was desperate for sex, the Belle for Sexaloitez, or so it appeared.

It's amazing how some people, when released from a lifetime's control, will automatically veer towards naughty or shocking behaviour. After hours trying to make sense of the ravings of this woman and rooting through her bag, I eventually made contact with her son. It turned out she was a priest's housekeeper. She had had cancer, thence the prosthesis, but she was also a manic depressive. Apparently, whenever her medication ran out she came to Dublin and went on a ripping sex rampage with a particular middle-aged man. She usually did this, got it out of her system and then returned home. But this time they had had a row so there was no one around to keep an eye on her. This transformation from her normal world of respectability to the unleashing in public of her locked-up longings was hilarious, though drastic, and all because she forgot to take a tablet. I wondered if there was a streaker hidden deep within all of us. Wouldn't it be fun if by massive coincidence everyone gave into that *exposé* desire all on the one night? The Gardaí would be in their element!

There is no doubt that the men in the Gardaí love the naked female form. They would have no interest in a stag night when the groom would be stripped and tied to a lamppost on O'Connell Street. They were quite willing to pass those calls over to the female Gardaí. How many times has my patrol jacket been used to preserve the decency of a much-embarrassed young man? It took a little while for me to learn how to keep a straight face when confronted by the hairy genitalia of such drunken victims. No, the male Garda lives in hope of that one call that comes every so often over the radio. 'There's a girl handcuffed to a bed and they've lost the key.' I heard this call from Control one night and it

took less than a few seconds for six cars to respond. Am I surprised?

At one stage I had in my possession three different sets of handcuff keys that came in very handy on many occasions, one for the official issue handcuffs, one for demonstrations when people would be handcuffed to gates, for example, and one for the furry sex toy types, useful on the aforementioned stag nights. One day I left them down on the desk in the Radio Room for five minutes while I went out to have a cigarette and when I returned the prize items were mysteriously swiped. I hope they came in as useful to their new owner — from a professional point of view, of course!

Perhaps it was because of this regular derangement in Store Street that its long-term members were more than a wee bit imbalanced themselves. I'm not just talking about the mania that would hit the station at Hallowe'en when the confiscated fireworks and bangers would be used to frighten the living daylights out of each other at unreasonable hours of the morning. One Garda Owen McGee in particular often sent my normally calm disposition into near heart attack terror when I least expected it. This went on from early September to mid-December when the Christmas madness would take over. I was lucky to survive Store Street with all my fingers and toes intact considering how closely those dreaded fireworks exploded near me.

The madness filtered through the ranks and penetrated into the social lives of the Gardaí themselves. I suppose dealing with prostitutes, pot-heads and potty situations, coupled with being allowed to drink in pubs until six o'clock in the morning because we were Gardaí, affected our perception of what normal behaviour was. We, the banners, were not viewed as women by our male

counterparts. Instead, we were viewed rather as pawns to be tried and tested for outrageous capers.

This aberration into loolah land came to my notice first in the guise of one of the Gardaí who ended up walking me home one night the five miles to Santry after a drunken session in town. We kissed. I thought no more about it, as I knew he was living with a girlfriend. But then he began to pursue me. Wherever I would go for a drink with the lads, this guy would show up. I did think it strange that on a couple of these occasions he brought his girlfriend along and made every effort for the two of us to get to know each other. I should have read the signal of what was to come when they both brought me up to their apartment for dinner one evening and he kissed me in the same room as his girlfriend while her back was turned. I quickly made my excuses and exited. And I really shouldn't have answered the call to go to a 'party' in their apartment a week later, except that I was badgered incessantly with phone calls begging my attendance. If the truth be known, curiosity got the better of me, but like the proverbial cat it also nearly killed me.

I made my way to the party, only to be greeted by said aroused Garda in an open dressing gown leaving nothing to the imagination. I was whisked into the bedroom and thrown on the bed beside his naked girlfriend. Needless to say there was no evidence of any party. Although one part of my brain knew instantly his intentions, the other part was numbed in disbelief. I took a glass of whiskey and downed it in one gulp. Awkwardly, I laughed the situation off and said, 'I'm not really into this', and left. It had me totally befuddled for a long time after that how this Garda could have thought I would partake in a *ménage à trois*.

I put it to him the next time I saw him. 'Yes, I've been priming you for a while,' he said. Apparently his girlfriend

had picked me out because she had been questioning her own sexuality. She had sanctioned the union between himself and myself to 'try me out' and he, in turn, gave the blessing for the girlfriend to go ahead. It never dawned on either of them to seek the permission of the third party! That encounter left me wondering what signals I had been sending out for quite a while.

I really didn't think I could come across any more perverted craziness. What I did think was that I would be wiser if it ever chanced my way again. Then I got a fanciful, girly crush on another Garda in the station. You would think I would have learnt. I believed this guy to be separated and therefore an open target for pursuit. He led me to believe this too. It was only when I had to race home to Offaly because my father had gone into hospital and I left a message on this guy's mobile telling him where I would be, that I discovered the truth.

Within two days I received a lengthy, angry letter in the post with a picture of said Garda naked in the bath with his son. Was it his wife that was threatening me? Not at all. This was his mistress and their love child. And yes, he was still married. She had traced the number I had left on his machine to my parents' house. It's a good job I was at home at the time, considering my mother's name is also Mary. Wouldn't she have got a right shock opening the envelope? The author of the scathing script was quite content to be the mistress but was going to make damn sure there were no others.

She rang me. His wife rang me. I discovered another girl at work was also having it off with him at the same time, not to mention countless others, thence the need for the mistress (not the wife) to hire a private investigator to keep an eye on all his activities! Was I glad to get out of that boiling pot.

Will it surprise you to learn that the Garda Síochána thought so highly of this boy that they've since promoted him? I suppose you could say he knows his job well, being clever to the world of deceit! Welcome to our world of insanity!

26

And it was from that world of insanity that I chose to leave after five years. Store Street station is a fantastic place for a young Garda. It's a great training ground for a rookie straight out of the academy and a true confidence booster. A trainee is thrown right into the fireworks on day one, and that's good. One of my sergeants, Andy Tallon, reckoned that he would have faith in any of his crew to handle any situation after doing a stint in Store Street. It was a measure of the calibre of the sergeants we had, not to mention the volume of work that was never-ending and varied. There was also a mighty camaraderie about the place and a mutual respect among all ranks and offices despite the odd rogue or two. Detective inspectors thought nothing of giving a helping hand or complimenting a junior member on a job well done, even if they were only a week or two in the city. I had tremendous, encouraging, competent sergeants and senior officers in Store Street. All doors were open to answer any questions. As I was making out my transfer request, I

figured that every station would be as helpful and as pleasant to work in. Oh, was I mistaken!

I applied for the IT Centre, the Computer Section of the Garda Síochána. It is based in Garda Headquarters in the Phoenix Park. My reason for wanting to go was that at the time a new computer system was being launched nationwide, called PULSE (Police Utilising Leading Systems Efficiently). In my mind I figured it would be great to get in there and get a handle on the system before everyone else, and in this day and age of advanced technology, knowledge of computers would be a great personal asset to have. Wouldn't it look good on the CV too? I had the border, I had Store Street, and a spell in HQ would be just the ticket to round it up nicely.

But nobody warned me that Garda HQ is littered with the cull from the herd. It sounds harsh I know, but it's my personal opinion. Perhaps at the age of 33 I expected to be treated as an adult by my sergeants. I found that the IT Helpdesk, which is where I have been detailed for the last five years, transported me right back to junior infants in primary school, to the days of the penal institution when it was a sin to express an opinion or question authority. My job is to help members in the stations use the new system and take calls on any problems they encounter. And there are a lot of problems as it is still a system in its infancy.

I joined the IT Centre at a time when there was huge change. There had been a cosy core section in there prior to the new system. To accommodate this change, a lot of Gardaí were transferred in. Most were quite junior and it had not been a voluntary move. There was the stifling air of mistrust about that reeked of the Templemore training. Everyone seemed afraid for their own position and unwilling to impart too much knowledge to the new folk in case someone proved intelligent enough to usurp their

positions. So we were badly trained and still are. Five years on I'm still taking members in the stations step by step through screens I have never actually seen because I'm not allowed to have access to them. That's a professional helpdesk for you!

I discovered early on that it was not going to be the font of mind expansion I had envisaged and which had been promised during the interview when applying. So about a year after joining there, when a job vacancy came up in the Air Support Unit (ASU), I jumped at it. I did not want to die bitter in an office.

I applied and got through the first round. The next hurdle to cross was a two-week assessment in Templemore with 20 others. When I say assessment what I actually mean is two weeks of being put through the wars. There was a mix of Gardaí and sergeants. For the entire period we were subjected to mental and physical extremes. It is similar to the assessment for the Emergency Response Unit (ERU), though slightly less painful. We only had to run half-marathons in full battle gear!

We hiked with heavy knapsacks till our bones ached. We abseiled off bridges and then free dropped a hundred feet into a river. We were let sleep no longer than two hours at a time and were woken at horrific hours to do either physical or mental tests. We had overnight stays in the middle of a cold field followed by exhaustive obstacle courses. We built rafts, survived in an emergency dinghy in the middle of a lake for many hours and climbed rock walls blindfolded through a clamour of riotous roaring. And that's only part of it. It was great!

At the time I was in training for a month-long expedition to Nepal. Nine others and I, who were raising money for the National Council for the Blind, were just back from an adventure snow-work weekend in the Scottish Highlands.

Our target was to climb the highest trekking mountain in the world, Mera Peak. At 22,000 feet it was no mean feat. I was the fittest I had ever been in my life and jumping out of my skin. I thrived on every minute of the two-week torture in Templemore.

I did the interview and my attentions turned to Nepal and more training. Working in the helpdesk, and how mind numbing it was starting to become, I was glad I had an outside interest. It was when I got back down to Lukla at 9,000 feet, after having been successful in my ascent of the mountain, that I got word from home I hadn't been successful in my bid for the Air Support Unit. I thought no more about it. I had just experienced the toughest, most arduous, contentious and exhilarating month of my entire life. I was totally spent and a skeleton of my former self. I went back to work at the helpdesk.

About three months later I received a very mysterious phone call from one of the members who had organised the pre-selection course for the ASU. He expressed concern that I had not been on the list. His office prepares the training and selects members for the ERU also. His team is a highly skilled tactics team trained to top standard for extreme situations. This person told me I had been one of the top three recommended from the course. He couldn't fathom how I had been omitted.

His concern was that, regardless of whom they were recommending for these high-risk jobs, their expertise was being ignored. He expressed grave reservations about certain members who had been picked for both the ASU and the ERU and their unsuitability for the dangerous nature of the jobs. He urged me to take action. Mind you, he did say he would never admit to our conversation.

I thought about it but let it pass for a while until the niggle became, if not anger, at least curiosity. In my own

mind I had raised an eyebrow at one or two of the boys who had been successful and how they had floundered through the two-week stint in Templemore. Obviously they had the connections which superseded competence. What had I to lose?

I carefully chose my words in a report I sent up through the ranks. I did not complain. I merely asked for my results from the pre-selection course so that I could prepare myself for a future application. I was not prepared for what followed. Senior ranks smell trouble even where there is none. I had no notion of taking any legal action of discrimination or unfair competition, but they apparently thought I did.

Officially, they sent me back a report saying they did not supply Gardaí with such information. However, a senior officer subsequently contacted me and said that I had better be careful not to start stirring what I couldn't handle.

I had looked into taking an action and was gaining support from the GRA who said they would back me if I did initiate something. But the gods had other plans. Just as I was investigating my options, my father had an aneurysm and died. He fell down in the shed and dragged himself across the yard to the house on a Friday evening. By Sunday morning he was dead. The ASU didn't much matter to me then.

I fell back into the ranks like a lamb and I'm still in the same position I was five years ago. I'm afraid I've become one of those wizened, cynical Gardaí I promised myself I would never turn into. As one other female Garda put it so succinctly when I asked her what she thought of her years in the Garda Síochána: 'They've knocked my lights out.' I'm also one of those non-effective, off the street Gardaí that sits in an office and does a job where Minister McDowell promises civilisation.

I remember years ago when I was at a loose end, I started a temporary job in the Department of Education in Athlone. My job was to make sure the teachers had added up the marks correctly on all the Intermediate and Leaving Certificate papers. I'm pretty good at mental arithmetic, so it didn't take me long to go through each bundle I was given. My enthusiasm was noted and I was called up to the top desk by one of the officers. 'Mary,' he said, 'the rest of these people have to work a certain number of weeks in the year to build up their stamps so they can draw the dole for the rest of the year. I know you're good but you're working too fast. Take more breaks. Just slow down.' I slowed down. I slowed down so much I got a good look at all the permanent civil servants working there. At the age of 18 I looked at them and I noted how pissed off they were with their jobs. There was a putrid air of lethargy and boredom about the office. I determined that summer that if I ever found myself in a similar situation, feeling like a zombie, unheard, I would quit my job. I may yet have to follow that promise.

I live in the hope of a dynamic, spirited leader taking over, but at the time of writing this, that would seem to be a far off stretch of the imagination. Only yesterday one of the higher ranks put his head in the door of the helpdesk. He was about to go home. 'How's everything going?' he asked. 'Is PULSE working OK?' I looked at him and said, 'Look, the whole system is down for the last two hours. We're getting nothing but complaints from all over the country. Members can't even do a car registration check and it's taking hours to process prisoners in the stations. It's a disaster.' So seriously did he take it, he put on his cap, did an about turn, and as he did so he said, 'Ah sure, it's all grand so.'